Sculpting *with* Light

TECHNIQUES FOR PORTRAIT PHOTOGRAPHERS

Allison Earnest

AMHERST MEDIA, INC. BUFFALO, NY

Dedication

To the two loves of my life: my children, Stephanie and Tyler. Thank you for your patience, love, and understanding throughout the creation of this book. Always remember: find your passion, believe in yourself, and never give up. If you believe, you will succeed!

To learn more about Allison Earnest,
please visit www.allisonearnestphotography.com.

Copyright © 2009 by Allison Earnest.
All rights reserved.
All photographs by the author unless otherwise noted.

Published by:
Amherst Media, Inc.
P.O. Box 586
Buffalo, N.Y. 14226
Fax: 716-874-4508
www.AmherstMedia.com

Publisher: Craig Alesse
Senior Editor/Production Manager: Michelle Perkins
Assistant Editor: Barbara A. Lynch-Johnt
Editorial Assistance: John S. Loder, Carey A. Maines, C. A. Schweizer

ISBN-13: 978-1-58428-236-5
Library of Congress Card Catalog Number: 2008926651

Printed in Korea.
10 9 8 7 6 5 4 3 2 1

Table of Contents

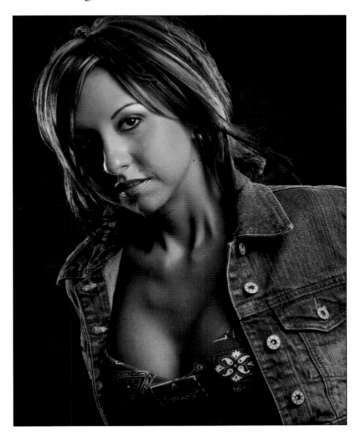

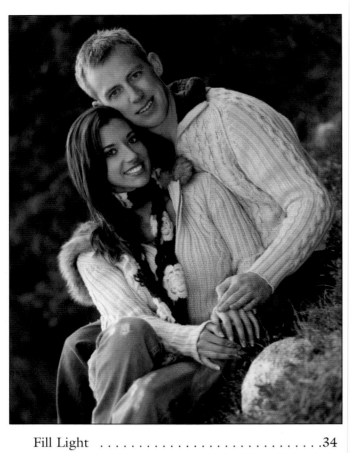

Acknowledgments

My passion for the photographic arts started twenty-four years ago. I am essentially self-taught, and were it not for the friendship and support of many people, this book would not have become reality.

Many talented photographers have shared their knowledge, which has brought me to where I am today. If I neglect to mention you personally, know that you are in my heart. First, I would like to thank Dave Howard, who recognized the passion for photography in a young, inexperienced photographer and hired me as a NASA photographer twenty-one years ago.

I thank my mentors and friends Jeff Johnson and Nick Vedros, who allowed me to absorb their many years of photographic knowledge unconditionally. Without their help and friendship this book would not be on the shelves. I thank Kevin Kubota for graciously sharing his actions and pushing me into the digital age. Kevin, you empowered me! Alice Miller, thanks for your friendship and for giving me the opportunity to pursue my secret dream of writing. My words can never convey just how much I appreciate your help. Eric Murphy, thanks for teaching me Photoshop and patience. I'd like to thank Dave Black for graciously spending time teaching me light painting.

Allison Earnest. Photograph by Ila Reinstein.

Bijan Pirnia, thanks for your philosophy on lighting; and Steve Clement, for your beautiful face-shape drawings.

Thank you to my friends at Wolf Camera in Colorado Springs, CO; Jerry, Thom, Lynn, Miriam, and Rich, who gave me unconditional help and support during the entire writing process. A big thanks to Eric Seymour, Jerry Ward, and Joe Adams for helping to keep me positive. Additional thanks go to: Erik Beard, David Mecey, Rolando Gomez, Ted Mehl, Bob Ray, Jeff Cable, Westcott, Suzanne D'Acquisto, Jon Asp, Tara Quigley, LumiQuest, Hensel Germany and USA, and Peter Geller of California Sunbounce (your products rock!), Marc Frederic Gottula and Sharon Leger Gottula, Heather J. ter Steege, and Howard and Doug (the CBL Lens is simply amazing!).

Thank you to all my models, friends, and clients who patiently sat in front of my camera. A special thanks to Alena Watters, Irena Murphy, Brian Caplan, and Michael Johnson for not only being wonderful models, but also great friends who were always there for me and ready to shoot for hours on end without complaints.

I would also like to thank my sister and best friend Connie for her love and support (don't send me a bill!). Thanks to Leslie Abeyta, Ila Reinstien, Marion Crocker, and Eileen and Mark Detka for your lifelong love and friendship. To my parents, my family, and Clay Earnest, thank you for believing in me, encouraging me, and allowing me to pursue my passion unconditionally. Without your support, I would not be here today.

Last but certainly not least, thank you to Amherst Media for all their help and giving me this opportunity to share with other photographers what I have learned about using light creatively in portraiture.

The Role of the Photographer

Contrary to what some people may believe, a photographer is more than a picture taker. A photographer is an artist who starts with a raw subject and sculpts it with light. Every subject, whether it's a person, place, or thing, requires well-placed lighting to enhance its appearance. While many other components make up a great image—lens choice, pose, props, and background—without light there can be no recordable image, no photograph.

Shaping the Image

The word "photography" comes from the Greek roots *photos* (meaning light) and *graphos* (meaning something that has been written or drawn). Therefore, photography can be comfortably translated as "writing with light." Like a writer, every time you create a photographic image, you share information, tell a story, and convey a message. Instead of using words, however, you use light.

A photographer is an artist who starts with a raw subject and sculpts it with light.

Whether you choose artificial studio light, the sun's natural light, on-camera flash, or a combination of both, light and the manner in which you modify, diffuse, and place it in relation to the subject is what distinguishes you, an artist, from a mere picture taker.

By combining light and creativity, photographers can shape a face, show texture, invoke mystery, and portray specific emotions within their images. This shaping is often referred to as chiaroscuro, an Italian term that refers to the use of light and shadows to create the appearance of three dimensions within a two-dimensional space. For hundreds of years, painters (and then photographers) have used this effect to their advantage. As photographers today, we are tasked with creating the appearance of three dimensions in our images.

Achieving Professional Quality

In the pre-digital era, the primary difference between professional and amateur photographers was the cameras, typically medium-format, used to capture an image and the lights used to illuminate it. Today, with digital capture the dominant means of capture for professionals and amateurs, it is technique not equipment that sets the two apart. In fact, the cameras and on-camera

flash units used by professionals and consumers are often similar, if not identical. Today, it is how you choose to light and sculpt your subject that determines the mood and feel of the final image, differentiating you from the amateur.

Light is the single most important piece of equipment a photographer must possess, and having a well-rounded knowledge of light's qualities and properties is essential. With a solid grasp of the basics, you will be able to use both natural and artificial light consistently and creatively to create beautiful portraiture.

As a portrait photographer, you will encounter a wide variety of people with vastly different facial shapes—some who feel comfortable in front of a camera and others who do not. Photographing people is about learning to "see" the light and designing a lighting strategy to accentuate your subject's strong features and downplay their flaws. The outer light (the light you use to record your images) is important, but remember that you are dealing with people and there is an art to finding their inner light as well. Once you understand the traditional lighting principles, you will feel more comfortable breaking the rules and creatively sculpting your subjects.

Digital vs. Film

The images throughout this book were shot primarily with digital capture, but some were captured on film. Although my emphasis is digital capture, the techniques can be produced with film capture just as easily.

Light is the single most important piece of equipment a photographer must possess.

1. The Physics of Light

Have you ever noticed that the colors in color photographs don't appear the same way we originally saw them? Of course you have. It's because the brightness and shades seen by the human eye are quite different than those recorded in a photograph.

What the human eye sees is not what will be recorded on film or on a digital sensor. The human eye adapts and adjusts to the color, saturation, and brightness or darkness of its environment. Film and digital sensors, on the other hand, record the actual colors and illumination rendered from the light source. For example, a camera records fluorescent light as green while the human eye sees it as a form of white. Understanding this phenomenon is key to producing images of the highest color and image quality.

What the human eye sees is not what will be recorded on film or on a digital sensor.

Perception of Light as Color

Visible light, the part of the electromagnetic spectrum that can be seen by the human eye, forms tiny bands of wavelengths among many other forms of energy. Shorter wavelengths, such as x-ray and ultraviolet light, can be detected by the human body because they penetrate tissue; longer wavelengths, such as infrared and microwaves, have no direct effect because the energy emitted is low.

It is only at wavelengths between 400nm and 700nm that the human eye registers what is perceived as light. Within this visible range, Isaac Newton

DIAGRAM 1—*When light emitted from a white-light source passes through a narrow slit and a prism, it separates into component wavelengths of different colors.*

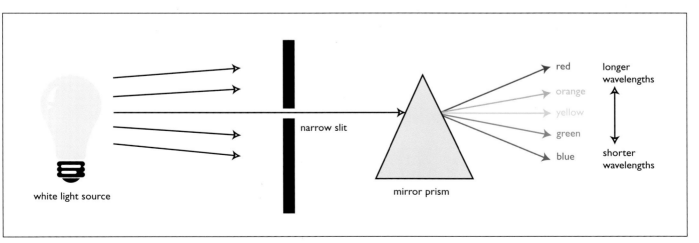

white light source · narrow slit · mirror prism · red · orange · yellow · green · blue · longer wavelengths · shorter wavelengths

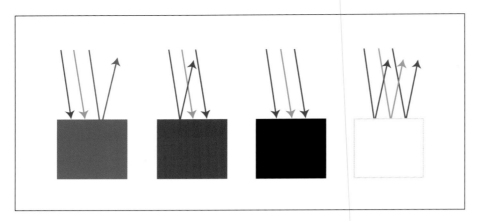

DIAGRAM 2—*Surfaces and substances absorb some wavelengths and reflect others. It is these reflected waves that create our perception of color. For example, blue subjects absorb red and green wavelengths but reflect blue wavelengths back to our eyes. Red subjects absorb blue and green wavelengths but reflect red wavelengths back to our eyes. Black subjects absorb all wavelengths, while white subjects reflect all wavelengths.*

proved that stimuli of different wavelengths produce all of the different colors. When we talk about color, we are actually referring to wavelengths of light that produce a particular color. For example, when we talk about "blue light" we are really referring to the wavelengths that elicit the sensation of blue. We see the world in a multitude of colors because some surfaces and substances absorb certain wavelengths and reflect others back to our eyes.

The chart below provides an overview of the energy (wavelengths measured in nanometers [nm]) and the color that is emitted.

Longer Wavelengths		
	Red	.800nm
	Orange	.640nm
	Yellow	.580nm
	Yellow-green	.530nm
	Green	.480nm
	Cyan (green-blue)	.450nm
Shorter Wavelengths	Blue	.430nm
	Violet	.390nm

Primary and Complementary Colors

Primary colors are a set of colors from which all other colors can be made. The primary colors for light (called the additive primaries) are red, green, and blue. The subtractive primary colors (usually used for pigments) are cyan, magenta, and yellow.

When all three additive colors are mixed together at full strength, the result is white. When any two additive primaries are combined, the result is one of the subtractive primary colors. Conversely, when all three subtractive colors are mixed together at full strength, the result is black. When any two subtractive primaries are combined, the result is one of the additive primary colors.

The visible spectrum's continuum of colors are often arranged in a circle called a color wheel. This wheel shows all of the primary colors, both additive and subtractive. Referring to this wheel makes it easy to evaluate another important relationship between colors: complementary colors. These are pairs

Primary colors are a set of colors from which all other colors can be made.

DIAGRAM 3 (LEFT)—*Combining all three subtractive primary colors (red, blue, and green) in equal parts forms white. Combining any two creates one of the additive primary colors (cyan, yellow, and magenta).*

DIAGRAM 4 (RIGHT)—*Combining all three additive primary colors (cyan, yellow, and magenta) in equal parts forms black. Combining any two creates one of the subtractive primary colors (red, blue, and green).*

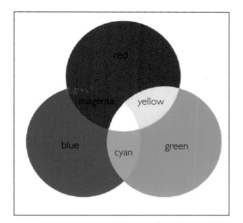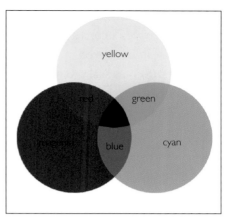

DIAGRAM 5—*The color wheel shows the relationship between additive and subtractive primaries. For any given color, the color directly across the wheel is its complement.*

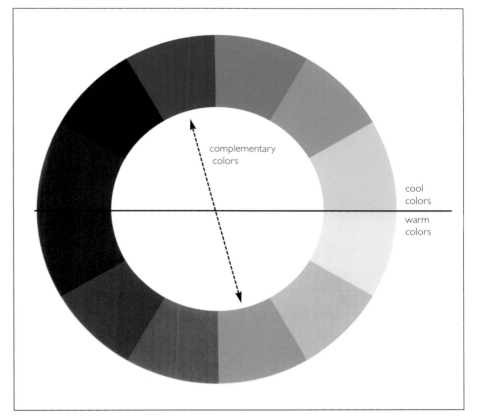

Becoming familiar with this theory will be very useful when designing portraits.

of colors that tend to contrast well with each other and, when combined in the right amounts, produce white. On the color wheel, complementary colors are located directly across from each other (such as blue and orange or red and green). Becoming familiar with this theory will be very useful when designing portraits—especially when making choices about backgrounds and clothing.

Color Temperature

In photography, the light we use to illuminate our subjects generally contains red, green, and blue wavelengths. However, they are rarely in the perfect balance that produces pure white light. Therefore, when considering the color of our images, we must also factor in the color temperature of the light emit-

ted by our light sources. Color temperature is measured in degrees Kelvin (K) and provides a consistent way of describing the degree of "whiteness" of a particular light source.

On the Kelvin scale, daylight is usually measured at 5500K. This is the same value to which on-camera flash and most studio light units are also rated. Light with lower temperatures is considered redder or "warmer;" light with higher temperatures is considered blue or "cooler," as seen in the chart below.

Color Temperatures of Common Light Sources

Burning candle	1900K
100-Watt light bulb	2850K
Halogen bulbs	3200K
Photofloods (continuous light)	3400K
Fluorescent (warm white)	3500K
Sunrise	4000K
Fluorescent (cool white)	4500K
High-noon sun	5400K
On-camera flash	5500K
Studio lights	5500K
Sunlight	4800–5800K
Sky (overcast)	5400–6200K
Computer monitor	5500–6500K
Fluorescent (daylight)	6500K
Clear blue sky	6200–7800K
Open shade	8000K

In most photographic situations, your aim is to balance the color of light to closely match daylight or 5500K, which yields the most pleasing and natural rendition of color—especially for portraiture. With digital capture, I find the automatic white-balance setting to be adequate in rendering most color temperatures and balancing most scenes to an acceptable "white." For more precise results, color temperature can be measured with a color meter—although most photographers can work without one if they become familiar with the chart above. Simply understanding the color temperatures of the sources you will commonly encounter goes a long way toward understanding how to control and manipulate the light in your final images. (*Note:* Another option that is relatively new to the market is a CBL [color balance lens]. Held in front of the camera during white balance evaluation, the CBL uses neutral points and prism technology to produce extremely accurate white balance readings. This works especially well in mixed lighting conditions.)

In most photographic situations, your aim is to balance the color of light to closely match daylight.

How We See Color vs. How the Camera Sees Color
The Human Eye. The human eye contains two types of photoreceptors cells: rods and cones. These are located on the outer layer of the retina at the back

of the eye. While the cones allow us to see different colors, the rods are used primarily for perceiving light and dark. For example, a person with fewer rods in his eyes may experience difficulty seeing in the dark. A person with abnormal cones in her eyes may experience partial color blindness, limiting her ability to differentiate between certain colors.

Furthermore, according to trichromatic theory, the human eye has three different types of cones: red, green, and blue. This enables us to perceive a multitude of colors. When cones that are sensitive to red are stimulated, we see red. When cones that are sensitive to green are stimulated, we see green. When red and green cones are equally stimulated, we see yellow—just as we saw in the additive primaries diagram on page 11.

Another factor in determining color is our learned behavior. If you grew up with a certain cone deficiency and your parents continually told you an apple was red, you would be conditioned to automatically say an apple is red. Similarly, in some cultures, classification of colors is limited to red, green, blue, and yellow—and all variations of blue, for example, are simply called blue. In Western culture, we have an abundance of names for blue and its many different shades and hues, such as navy, indigo, and cobalt. It just goes to show that even cultural aspects have a lot to do with how we perceive colors.

Finally, it is important note that our eyes and brains also actively work to balance and neutralize colors, a phenomenon called chromatic adaptation. This is why a red apple always looks red, whether you are looking at it under a greenish fluorescent light or in the light of a pinkish sunset.

The Camera. Like the human eye, digital cameras are sensitive to red, green, and blue light. Films are also sensitive to some or all of the same spectrum. Unlike human eyes, however, cameras are totally objective; cameras record the actual color of the light striking the image-recording medium. This can cause what appear to be discrepancies between what we see with our eyes and what we see in our images. For example, we may look at an area of white or gray in a shaded scene and see it as white or gray because our eyes have compensated for the actual bluish cast in the scene. An image of the same scene captured either on film or a digital sensor, however, will record the *actual* color of the light—hence, the white or gray will be recorded as bluish in color. This might be acceptable for artistic or abstract images but definitely would not be flattering when photographing people.

Understanding light and learning to "see" color is a key component in becoming more discerning with regard to the final portraits you create or receive from your photo lab. You need to be aware of what goes into creating exceptional color so that your clients receive the most professional portraits possible.

Like the human eye, digital cameras are sensitive to red, green, and blue light.

2. Incident and Reflected Light

*L*ight is your paintbrush, and only when the qualities of light are thoroughly understood can you control, manipulate, and sculpt a portrait to capture your subjects at their best. With regard to portrait photography, there are essentially two basic categories of light: incident and reflected light. Later in this chapter, we will look at how these two types of light can be measured to ensure an accurate exposure. First, however, we will consider the additional qualities of light that play a role in the look of your final image.

Incident Light

Incident light is the light that falls on a subject, either directly or indirectly. Direct sources of incident illumination are sources that emit light, like the sun or a strobe unit aimed at the subject. Indirect sources of incident illumination redirect light onto the subject. These could include a wall from which sunlight bounces back onto the subject or a reflector that redirects light from a strobe onto the subject. In both cases, the light is reaching the subject and can be metered and controlled.

This results in a sharp, more dramatic look that tends to accentuate form and texture.

Intensity. The intensity of the light refers to the amount of light illuminating or "falling on" the subject, whether directly from a light source or indirectly from secondary sources of reflected illumination. The intensity of the light can be measured objectively with a light meter and controlled with the use of light modifying techniques, which will be addressed in chapter 3.

Hard *vs.* Soft. Lighting is often described as being hard or soft. Hard light is light that creates a rapid shadow-edge transfer between highlight and shadow areas. This results in a sharp, more dramatic look that tends to accentuate form and texture. Soft light is light that creates a broad shadow-edge transfer between highlight and shadow areas. This results in a more gentle look that tends to smooth forms and texture. Although most traditional portraits are made with a soft light source, it is quite acceptable

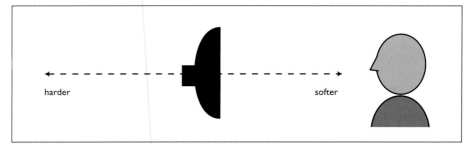

DIAGRAM **6**—*The relative size of the light source in relation to the subject is a controlling factor in the quality of the light. This is controlled by both the physical size of the source and its distance to the subject*

to use a hard light source (or a combination of both) to produce images that reflect your personal style.

Size and Distance of the Light. The size of your light source and its relative distance to your subject are both controlling factors in the light quality that will be produced. The smaller your light source is in relation to your subject, the harder the light will be. The shadow-edge transfers will be sharper and the image will have more defined shadows. The larger your light source is in relation to your subject, the softer the light will be. The shadows will be less defined and the light will have more of a "wrap-around" quality.

The larger your light source is in relation to your subject, the softer the light will be.

Let's use the sun as an example. The sun is physically a huge source—870,000 miles in diameter. However, it is also extremely far from us here on earth. On a bright, cloudless day, the sun is quite small relative to a subject being photographed outdoors, thus the quality of light will be hard. On a cloudy day, the sun is still the same size and distance to the subject, but the clouds act as a massive diffusion panel that is much closer to the subject. This scatters the light in many directions and produces a softer quality of light.

To illustrate the harsh shadow effects of direct sunlight, Irena Murphy and Rita Serby were photographed on a sunny day with no fill (plate 1). An inci-

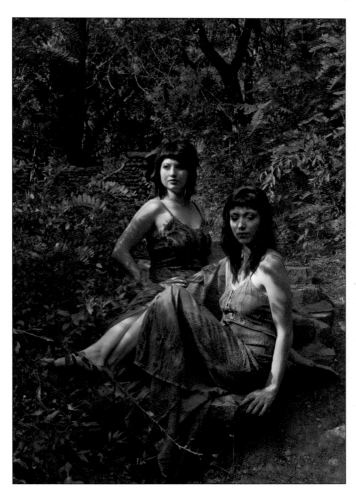

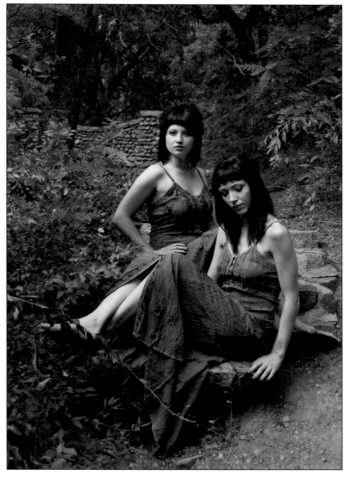

PLATE 1—*Hard light from direct sun. (ISO 100, ¹/₆₀ second, f/8.0)*

PLATE 2—*Light softened with a Sunbounce translucent white panel. (ISO 100, ¹/₈₀ second, f/4.5)*

dent-light exposure was measured and the camera was set accordingly. As you can see, the sun was behind a tree that cast harsh shadows throughout the portrait. To eliminate the shadows on the models, they could have been repositioned with the sun behind them; however, this would have compromised the desired composition.

Waiting for the sun to move behind a cloud would have softened the harsh shadows and retained the desired composition, but time was of the essence. The models were only available to shoot for one hour, so we simulated a cloudy day by placing a 4x6-foot white California Sunbounce translucent panel to camera left (plate 2; previous page). The panel diffused the harsh sunlight, producing a softer shadow-edge transfer. (Here's a good reminder: Always carry a few universal clamps in your camera bag. On this day, I forgot to pack the clamps. As there was no room for a light stand, the panel had to be placed in the trees for this shot—and when the wind came up, the panel kept falling out of the trees and onto the models.)

Things work just the same way inside the studio. A bare strobe head is very small, producing hard light. Attaching a softbox makes the light source larger, producing softer light. However, if you move even a large softbox too far back from the subject, it will become small in relation to the subject and record as a hard light source. The mere attachment of a soft diffuser over a light source is no guarantee the light will be soft; positioning the light correctly is also critical.

Direction. The placement of the main light source relative to the subject is another controlling factor in the quality of the light in your final portrait. Light travels in a straight line, but when it strikes a surface, its angle of incidence is equal to its angle of reflectance. For example, with front lighting, the light is directly at or behind the camera, producing a zero-degree angle of incidence and thus a zero-degree angle of reflectance. The result is flat lighting. If the light source is moved 45 degrees left or right of the lens axis, it will reflect back at the same 45-degree angle. This concept is important when positioning your light and modifiers to show shape and create depth on your subject.

The mere attachment of a soft diffuser over a light source is no guarantee the light will be soft.

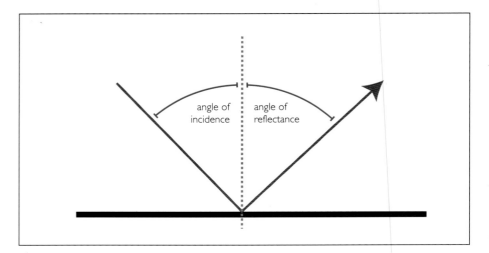

angle of incidence angle of reflectance

DIAGRAM 7—*The angle of incidence is equal to the angle of reflectance.*

Contrast. Contrast describes the difference in brightness between the highlight and shadow areas of a photograph. This can be controlled by subject placement, light placement, and the use of light modifying tools and techniques (see chapter 3). Just as the clouds in the sky control the relative contrast of the sun, you can actively control the contrast within an image. In portrait photography, contrast is often discussed in terms of lighting ratios, which are covered in chapter 4.

Reflected Light

Reflected light is the light that bounces off your subject and other elements in the scene. Like incident light, it can be measured in quality and quantity, enabling you to readily define the mood of the image.

In portrait photography, for example, subjects with dark skin tones reflect less light and absorb more light than subjects with lighter complexions. Therefore, subjects with dark skin will require more exposure or light (a minimum of one full stop or twice as much light as light-skinned subjects) to obtain an accurate rendition of their skin color in a final image. The reverse is true for subjects with light skin tones.

The light being reflected from the surrounding areas will also affect your image. For example, a white room will reflect more light than a room with dark walls, altering the actual subject brightness and contrast ratio.

Metering the Light

Whatever type of lighting you choose to create an image, it is imperative that you meter the scene to obtain the correct exposure and contrast (for more on this, see Lighting Ratios on page 48). There are essentially two metering techniques: reflected-light metering and incident-light metering.

Reflected-Light Metering. Reflected-light meters are the type of meters built into cameras, but reflected-lighting metering is also available as a feature on many hand-held light meters. Reflected-light meters measure the amount of light that is reflected by your scene or subject. This is not the ideal metering technique because it takes a reading of the entire scene (highlight and shadow areas) and provides an averaged reading designed to record the scene or subject as 18-percent gray (also called middle gray). This gray is a standard value designed to provide a safe exposure for "average" subjects.

But what happens with subjects that are not average? For example, imagine you use your camera's reflected-light meter to evaluate the exposure of a bride in a white dress. The light meter would see a lot of light being reflected by the dress and, to balance it to middle gray, recommend a lower exposure than is needed. As a result, the image will be underexposed and the dress will look gray. Conversely, imagine taking a reflected-light meter reading of a groom in a black tuxedo. The light meter would see very little light being reflected by the tuxedo and, to balance it to middle gray, recommend a higher exposure than is needed. As a result, the image will be overexposed and the tuxedo will look muddy.

It is imperative that you meter the scene to obtain the correct exposure and contrast.

Both of these problems are the result of measuring reflected light from the subject rather than the actual light falling on the subject. As a result, this metering may be adequate for amateur picture-takers, but it is not an optimal metering practice for portrait photography. (*Note:* That is not to say that professionals never use reflected-light readings. Sometimes it is impractical to take a reading from the subject position or of a far-off background, as is required with incident-light metering [see below]. In these cases, using a reflected-light reading may be neccessary.)

Incident-Light Metering. A more accurate metering method is to use an incident-light meter. This type of hand-held light meter measures the amount of light falling on the subject. When you measure the light before it falls on the subject, you will achieve consistent results regardless of the color of the subject you are metering. Because your reading is independent of the subject, a white wedding dress will record as white and a black tuxedo will record as black.

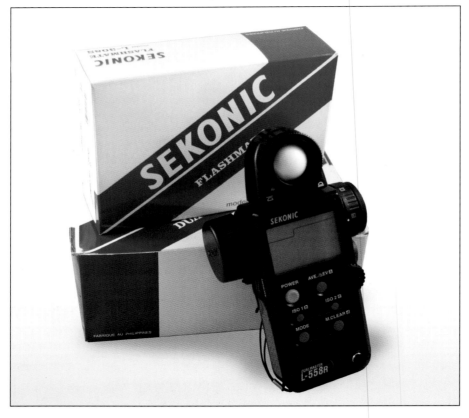

PLATE 3—*Many types of light meters are available. Some meters record only flash exposure, others read only incident light. When investing in a light meter, it is wise to purchase one that records both flash and ambient exposure. The Sekonic L-588R is one such meter. Designed especially for digital, it is quite accurate.*

To obtain an accurate incident-light meter reading of your subject when shooting with continuous light, set the meter to the ambient metering mode. Then place the hand-held meter at your subject's position and point the dome back at the camera. Most meters have a 180-degree angle of view when using the white dome meter on the front. Other meters also come with a flat accessory (which is used in place of the dome) that meters light coming in from only one direction. This is ideal when you are determining the exposure-compensation value of a filter to be placed on your lens or when you need to

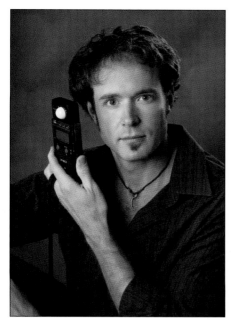

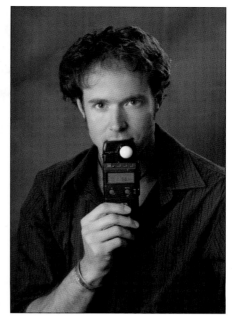

PLATE **4**—*In this image of Brian Caplan, the light meter dome is pointed toward the main light source to read the amount of light illuminating the subject. The corresponding aperture or f-stop will appear on the meter's LED screen with the actual exposure of the main light source. You may need to increase or decrease the power of your strobe to obtain the desired f-stop. When working with strobes, your exposure is controlled only by your f-stop, not by your shutter speed. More on this later. (Manual mode; ISO 100; $^1/_{250}$ second; f/9.0)*

PLATE **5**—*Without repositioning Brian or the light source, an exposure of the shadow side of his face is recorded in the same manner as the highlight area. To add separation from the background, a small light source was placed behind the subject and to camera right. When using multiple lights, be sure to shield the excess light from reaching the meter, as this will interfere with your exposure. (Manual mode; ISO 100; $^1/_{250}$ second; f/9.0)*

PLATE **6**—*The exposure recorded on the light meter will be your final exposure. An exposure value of f/5.6 was recorded and the aperture was set on the camera accordingly. When using a studio strobe, always set your camera to manual. This will allow you to properly set your exposure without any influence from the camera's built-in light meter. (Manual mode; ISO 100; $^1/_{100}$ second; f/5.6$^1/_2$)*

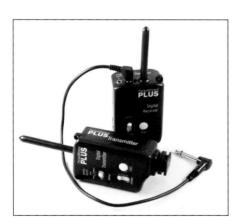

PLATE **7**—*Using a PocketWizard, strobes can be triggered remotely, allowing you to take an incident-light meter reading from the subject's position.*

take a reflected-light reading from a more concentrated area than is possible with the dome. (*Note:* For example, you might take a reflected-light reading of a background to determine its value relative to the subject.)

Once you have taken your reading, adjust your camera's shutter speed and f-stop to the setting indicated on by the meter. Should you want to produce an image with shallow depth of field (using a larger aperture), the meter will give you the corresponding shutter speed for your desired aperture.

If you want to shoot with flash, rather than a continuous light source, switch the meter's mode to flash. You can then use the same metering method—just trigger your flash remotely to determine the amount of light illuminating the subject. When using multiple strobes, be sure to meter each light separately with the dome facing the strobe that is being measured. This technique will help you to determine the amount of light on your subject(s) from each source.

3. Light-Design Tools

With film capture, the type of film selected typically indicates what type of light source to use (or vice versa; the light to be used determines the film choice). For example, with tungsten film loaded in your camera, your only option was to use continuous "hot lights" with a temperature rating of approximately 3200K. If you had daylight film loaded and only had access to a tungsten light source, you would have to use an 85A blue color-compensating filter over the lens to balance out the light to a neutral "white." But there is a downside to using color-compensating filters: the loss of two full f-stops. This may not be ideal for every subject or situation. When photographing people, for example, it is important to have a minimum aperture of f/8 to maintain the sharpness of your subject's nose and eyes. With digital capture, any one of the lighting design tools listed below will work beautifully, because changing the color temperature (*i.e.*, the white balance) in your camera is accomplished with ease and without sacrificing exposure.

I have dedicated this section to the three most popular lighting tools that are common in portraiture: on-camera flash, studio strobes, and photofloods. Each has its advantages and disadvantages. Understanding how each lighting

There is a downside to using color-compensating filters: the loss of two full f-stops.

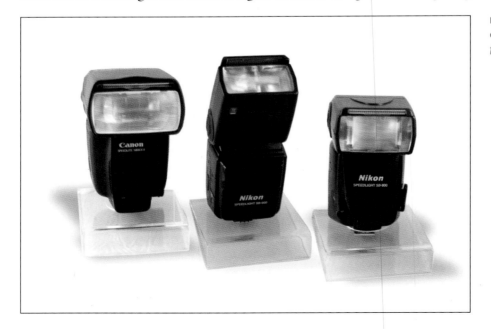

PLATE **8**—*Electronic flash units designed for on-camera use are reasonably priced and very portable.*

tool works will help you show your subjects in their best light. I have chosen a particular brand of lighting equipment, though any lighting product with similar features can be used with good results. The idea is to familiarize yourself with the basic features and functions of the different types of lighting tools then determine which works best for you.

On-Camera Flash

Electronic flash units, or speedlights, are portable, reasonably priced, balanced for daylight, and easy to use. Most flash units can even be remotely controlled to provide a simple multi-light setup for location portraiture. The drawback is that flash units create harsh light because of their small size. Additionally, when not used properly, they produce unflattering, flat frontal lighting.

Let's look at a few examples. My long-time friend and model Alena Watters and her friend and fellow actor, John Rochette, came to my studio wanting me to create headshots for their comp cards. During the shoot, they were gracious enough to allow me to make several illustrations for this book, as well. For the first shot, I attached an on-camera flash. The camera was set on program mode and the flash was set on automatic TTL (through the lens). The result was this flat rendition of a lovely couple (plate 9). Basically, this image is an example of an amateur snapshot.

PLATE **9**—*On-camera flash often produces flat lighting. (Program mode, ISO 100, $^1/_{60}$ second, f/4.2)*

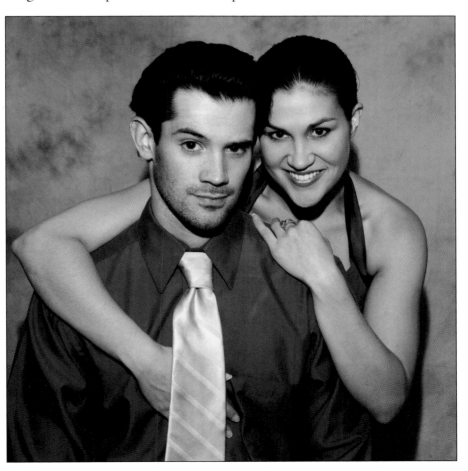

Fortunately, a wide variety of portable light modifiers are available. These come in many shapes and sizes and are designed to diffuse, soften, and redirect the small light source from your on-camera flash. These offer superior results, particularly when used in conjunction with bounce techniques, and can help soften the light effectively.

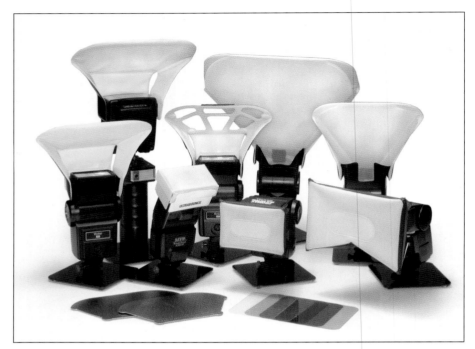

PLATE 10—*LumiQuest offers a wide variety of portable and quite efficient small light modifiers that attach directly to your flash with Velcro strips. Photograph courtesy of LumiQuest.*

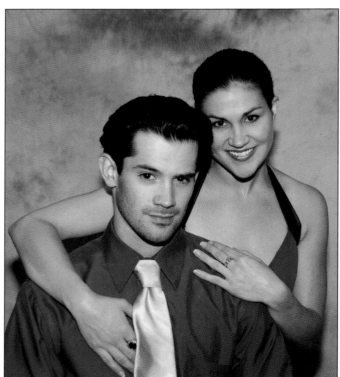

PLATE 11—*Using a bounce attachment softened the light. (Program mode, ISO 100, ¹/₆₀ second, f/4.3)*

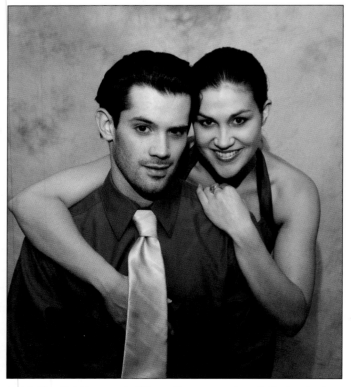

PLATE 12—*Light bounced off the ceiling can create unflattering shadows on the eyes. (Program mode, ISO 100, ¹/₆₀ second, f/4.3)*

PLATE 13—*Using studio strobe rather than on-camera flash allows you to create a much more sculpted look. (Manual mode, ISO 100, $^1/_{125}$ second, f/13)*

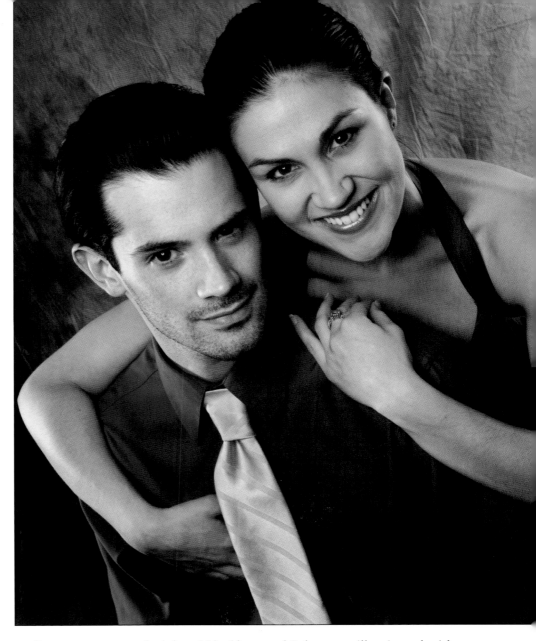

The additional accent lights add a tremendous amount of depth to the portrait.

In our next example (plate 11), Alena and John were illuminated with a Nikon SB-800 Speedlight with a LumiQuest light modifier attached to the flash. The bounce attachment redirected the light from the flash and softened the light on the subjects. Notice that the shadows now fall slightly behind the couple. Another variation was created by bouncing the flash up toward a nine-foot ceiling (plate 12). This softened the light falling on the subjects, but notice the unpleasant shadows it created on their eyes.

As a frame of reference, I have included an image of the same couple photographed with sculpted studio strobe. For this image (plate 13), Alena and John were illuminated with a Hensel Integra 500 monolight and two accent lights on each side of them. Notice how the additional accent lights on either side of the couple add a tremendous amount of depth to the portrait. You can readily see the difference in the depth and dimension of the sculpted image when compared to the on-camera flash image

Studio Strobe

Unlike electronic flash, AC-powered studio strobes are ideal for shooting inside a studio setting. With the use of a portable generator or battery supply, studio strobes work well outside, as well. The daylight-balanced flash tube fires at a rate of approximately $\frac{1}{50,000}$ second and are the primary source of exposure on the subject.

Modeling Lights. Studio flash units are equipped with a modeling light adjacent to the actual flash tube. This provides a continuous source of light, simulating the effects of the actual light that will fall on the subject during the flash exposure and allowing for better control of light placement and easier focusing. Though modeling lights can be adjusted independently of the flash tube, their power is very low relative to the flash tube. There is essentially no effect on final exposure when using shutter speeds above $\frac{1}{30}$ second.

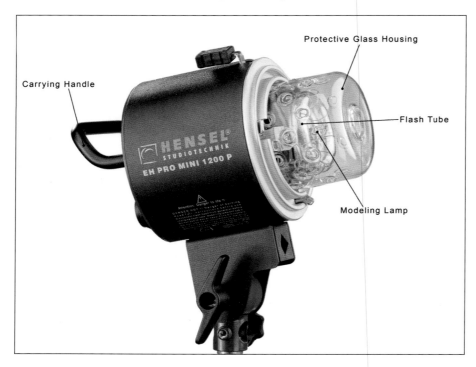

Protective Glass Housing

Carrying Handle

Flash Tube

Modeling Lamp

PLATE 14—*The Hensel Pro Mini 1220P consists of a modeling light and flash tube. Photograph courtesy of Hensel Studiotechnik Germany (Graphics by Jeff Johnson, Original Image Co.).*

Types of Strobes. There are two basic types of daylight-balanced studio strobes from which to choose and both have their associated advantages and disadvantages.

Monolights are integrated strobes that house their power supply, circuits, capacitors, flash tube, modeling light, and reflector in one self-contained unit—meaning fewer power cords to trip over. The advantage of using monolights is that each unit's output can be controlled independently. Because each monolight's power supply is self-contained, it is relatively simple to determine exposure ratios and adjust intensity to create a certain look. For example, if you are using two 1000Ws (Watt-second) monolights, when both are on full power their combined output is 2000Ws. When one light is adjusted to half power, the combined wattage for both monolights will be 1500Ws—one light at full power (1000Ws) and one at half power (500Ws).

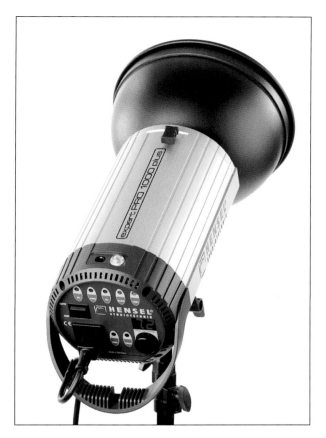

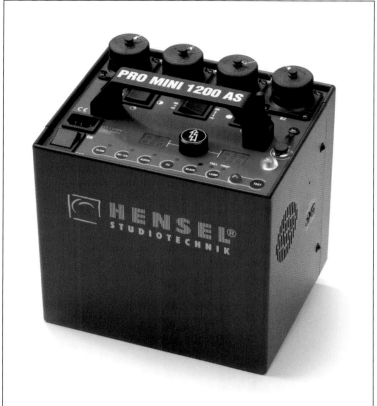

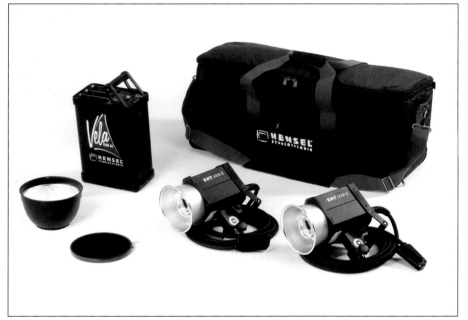

PLATE 15 (TOP LEFT)—*The Hensel Expert PRO 1000 plus monolight is a self-contained flash unit with a built-in radio slave, so one transmitter is sufficient for all units. The flash power can be adjusted in a range of six stops in $^1/_{10}$-stop increments, for even the smallest fine-tuning of exposures. Photograph courtesy of Hensel Studiotechnik Germany (Graphics by Jeff Johnson, Original Image Co.).*

PLATE 16 (TOP RIGHT)—*The Hensel Pro Mini 1200 AS power pack is designed with two generators that provide asymmetrical or symmetrical distribution. This small portable system has four-channel radio-controlled triggering and power settings that can be adjusted in $^1/_{10}$-stop increments. Photograph courtesy of Hensel Studiotechnik Germany (Graphics by Jeff Johnson, Original Image Co.).*

PLATE 17 (RIGHT)—*A Hensel Vela power pack system with two light heads. Most systems come complete with a carrying case that makes traveling to different locations easier. Photograph courtesy of Hensel Studiotechnik Germany (Graphics by Jeff Johnson, Original Image Co.).*

Unlike a monolight, the power supply for a power-pack system is housed in a separate box-shaped unit that is designed to accommodate two or more flash heads. When using more than one flash head, some units allow for equal (symmetrical) distribution between heads, while others allow for asymmetrical distribution to various heads, which makes calculating exposure a bit more complicated. For example, if three flash heads are plugged into a 1500Ws

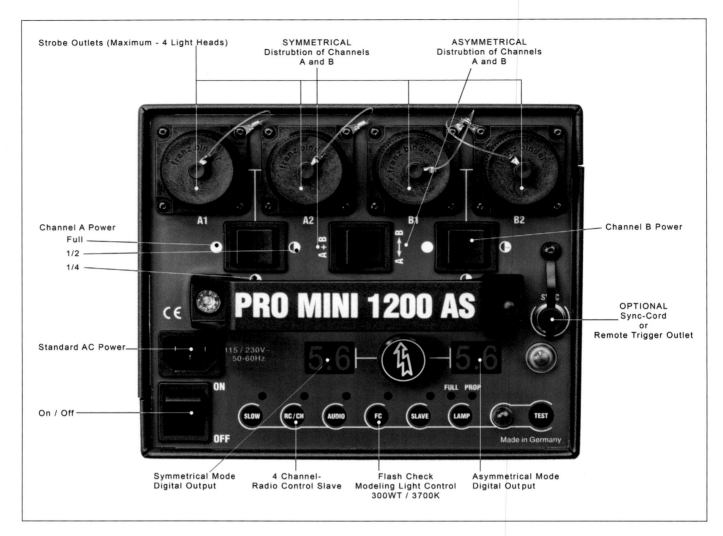

Strobe Outlets (Maximum - 4 Light Heads)

SYMMETRICAL
Distrubtion of Channels
A and B

ASYMMETRICAL
Distrubtion of Channels
A and B

Channel A Power
Full
1/2
1/4

Channel B Power

Standard AC Power

OPTIONAL
Sync-Cord
or
Remote Trigger Outlet

On / Off

Symmetrical Mode
Digital Output

4 Channel-
Radio Control Slave

Flash Check
Modeling Light Control
300WT / 3700K

Asymmetrical Mode
Digital Output

separated power supply, each flash head would have an output of 500W of power, a symmetrical distribution. Some power pack units are equipped with channels, so that two lights share a power supply and a third light has its own power, allowing for symmetrical and asymmetrical distribution.

Continuous Lights

Commonly referred to as hot lights or photofloods, this type of light produces a continuous output of light rather than a "flash" or strobe effect. As a result, you can observe the actual light (the light that will be used to make the exposure) falling on your subject as you set the lights; you do not need to rely on a separate modeling light.

Traditionally, the drawback to using hot lights was that they were balanced for warmer temperatures, such as 3200K. Additionally, they could generate a lot of heat and could not be used for extended periods of time without problematic heat buildup. Today, however, there are continuous lighting systems entering the marketplace that are daylight-balanced to 5500K and do not generate as much heat as earlier systems. A popular example is the Westcott Spider Light (plate 19), a uniquely designed system that accommodates five

PLATE 18—*On the Hensel Pro Mini 1200 AS, if using two flash heads plugged into channel A1 and B2 with the A+B switch selected each flash would have an output of 600W—a symmetrical distribution of light going to each flash head. If you add a third light and plug it into channel B1, the output for channel A would remain at 600W, but each light head on channel B would have a divided output of 300W. Photograph courtesy of Hensel Studiotechnik Germany (Graphics by Jeff Johnson, Original Image Co.).*

daylight-balanced (5500K) lights into one light head and has a low heat level that allows the lights to be used for an extended period of time.

Unlike with strobe lighting, where the aperture is the most important control when determining exposure, when using continuous lighting, your shutter speed and aperture are equally important.

Light Modifiers

A light modifier is an attachment that is placed on your light source to diffuse or redirect the light. The type of light modifier you choose will determine the feel or "mood" of the final portrait.

For Soft Light. Light from white umbrellas, softboxes, white reflectors, and translucent scrims; light bounced from textured and rough surfaces; an

PLATE 19—*Westcott Spider Lights are a popular continuous light source.*

PLATE 20—*Umbrellas (left), beauty dishes (center), and softboxes (right) are all used to soften light.*

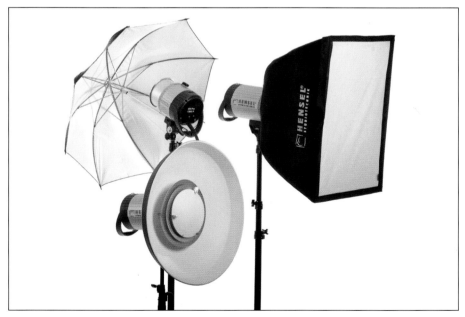

PLATE 21—*Suzanne D'Acquisto of Colorado created this image of Fran and Jim Lomontagne using soft window lighting. (Manual mode, ISO 400, $^1/_{125}$ second, f/8)*

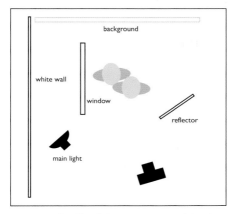

DIAGRAM 8—*The lighting setup used in plate 21 (facing page).*

PLATE 22—*Light modifying attachments such as: (left to right) parabolic reflectors, grids, barn doors, and snoots all produce a hard directional source of light.*

overcast sky—all of these sources will produce a soft shadow-edge transfer. With these larger sources, the light is scattered, making it softer and more diffused. Remember, as noted in chapter 2, that large modifiers placed close to the subject will produce a softer light quality; as you move them farther from the subject, however, the light will become progressively harder.

Plate 21, by photographer Suzanne D'Acquisto, clearly illustrates the effects of soft lighting. Suzanne's main light was a large window that produced light that wraps around the subjects. Notice how her subjects were placed close to the window. This made it act just like a large softbox, creating soft shadow-edge transfers. This lighting is ideal to soften imperfections on the facial mask.

For Hard Light. Bare bulbs; parabolic reflectors; grids; snoots; bounced light from smooth, shiny surfaces (such as silver and gold reflectors); and cloudless sunny daylight—these sources all produce a hard quality of light. With these sources, the shadow-edge transfers will be more defined; the lighting will look hard and directional. Again, it is important to note that the quality of the light is directly related to the placement of the light relative to the

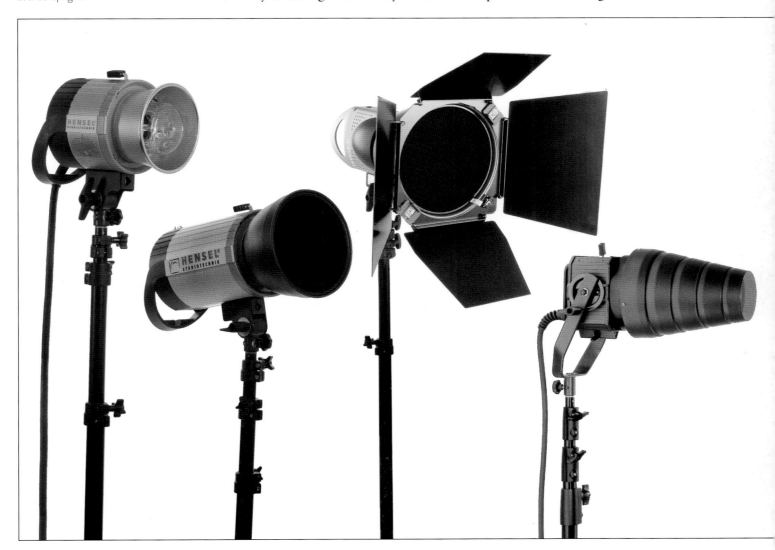

subject. You can produce a hard quality of light by placing a softbox farther away from the subject.

My mentor Nick Vedros was gracious to allow me to use his fine portrait of Guns, a Vietnam Vet, to illustrate hard lighting (plate 23). In the image, Guns is holding a portrait of himself in Vietnam when he was only nineteen years old. Though Nick created this image with a softbox, it was placed at a distance from the subject to create a harder quality of light. The reason for this decision was that Nick wanted to bring out the subject's rough facial texture in the portrait.

For No Light. Gobos (short for "go-betweens"), flags, and barn doors are often used to shape and sculpt light by blocking it from reaching a par-

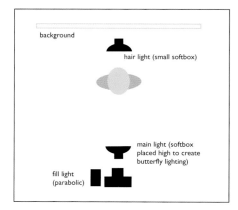

DIAGRAM **9**—*The lighting setup used in plate 23.*

PLATE **23**—*Nick Vedros used hard lighting to emphasize the texture of this subject's face. Nick lights his subjects with what he calls "interpretive" lighting, evaluating the specific subject and creating a quality that works for the portrait at hand. Nick tries to avoid formula lighting.*

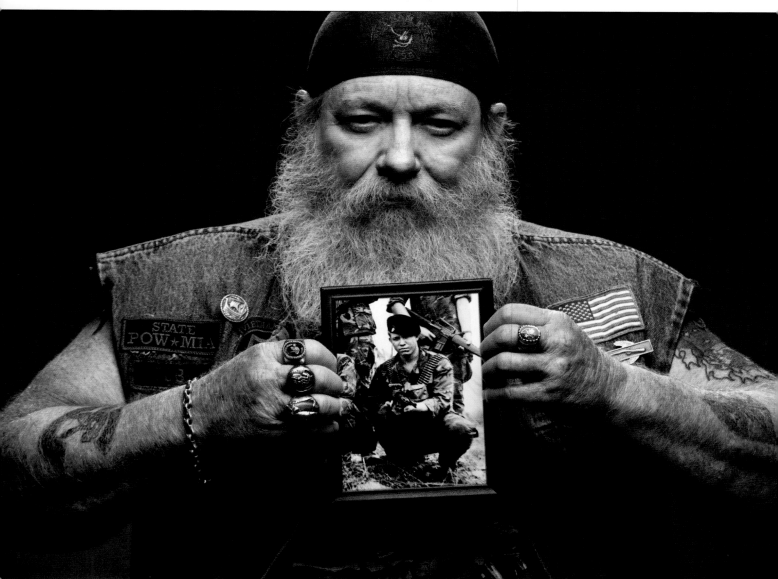

PLATE **24**—*California Sunbounce offers a large variety of reflectors, scrims, and gobos that will help you block and redirect your light on your subjects.*

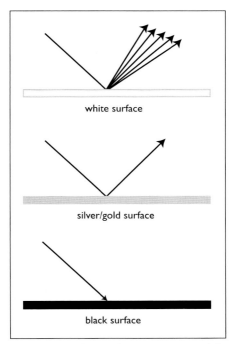

white surface

silver/gold surface

black surface

DIAGRAM **10**—*The surface characteristics of a reflector or gobo determine the impact it will have on incident light.*

Gobos block all of the light, preventing it from reaching the subject.

ticular area of an image. Because gobos are typically black, they block all of the light, preventing it from reaching the subject.

Light Painting

Light design tools don't have to be expensive—or even very sophisticated. Dave Black of Colorado graciously introduced me to an artistic photo technique called light painting. The concept is previsualizing your final photo and literally painting light onto your subjects with a flash light and/or spot light while the camera's shutter remains open. Using this technique, plates 25 and 26 were created with only an INOVA 3.8 flashlight and a spotlight purchased at a local hardware store.

Plate 25, with its beautiful painterly quality, was created during a private class on light painting with Dave Black. I chose Irena as my subject because she has beautiful features and I was confident she would have the patience to hold a pose for thirty seconds—a feat in and of itself. The setting was Suzanne D'Acquisto's Colorado studio, and her piano was used as a prop. The antique prom dress was chosen for its vintage feel that complemented the antique piano. I placed additional props on the piano to add a sense of depth and character.

Secure on a tripod, my Nikon D-200 was placed on manual mode, allowing me complete control over the shutter speed and f-stop. Dave Black suggests a starting shutter speed of thirty seconds at f/5.6 for this type of image. With the studio completely dark, Irena in my chosen pose, and flashlight in hand, I moved the flashlight to selectively illuminate portions of the scene. Remember that your shutter remains open for thirty seconds, so your model must remain extremely still for the entire exposure or you will record their movement.

Light painting can also be used outdoors, as long as you shoot at night. Plate 26 was created in Suzanne D'Acquisto's backyard with an old jalopy as

I was confident she would have the patience to hold a pose for thirty seconds.

PLATE **25**—*During a thirty-second exposure, the subject held her pose while a light was moved over her. (Manual mode, ISO 200, 30 seconds, f/5.6)*

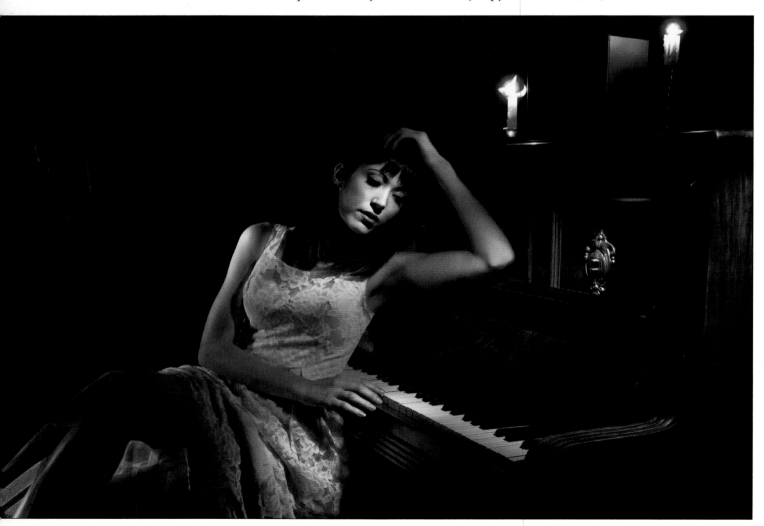

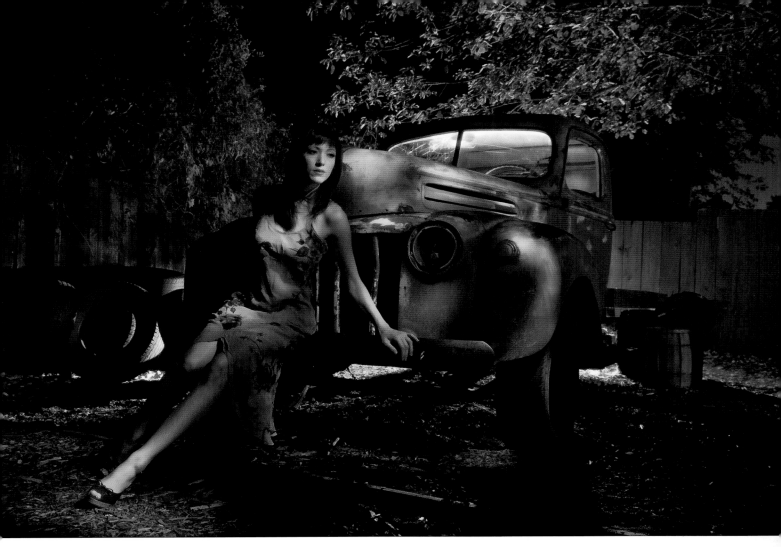

PLATE 26—*Using a two-million candlepower spotlight and an INOVA flashlight, light was painted onto the scene and subject. (Manual mode, ISO 200, 30 seconds, f/5.6)*

the perfect prop. Notice how the clothing choice compliments the surrounding props. With my Nikon D-200 on a tripod, Irena in my desired pose, flashlight and spotlight in place, I proceeded to selectively light the scene. Dave, Suzanne, Irena, and I created a number of images, shooting at close to midnight. If you have the opportunity to attend one of Dave Black's many photography classes, take it. He is passionate about photography and is quite the comedian. We all laughed, learned, and had a wonderful time exploring the possibilities of light painting.

4. Portrait Lighting Basics

*I*n nature, there is essentially one light source: the sun. Accordingly, traditional portrait photographers are taught to light a portrait so that it appears to be lit from one light source, regardless of whether it is produced inside or outside the studio. The following examples are the basic, traditional lighting techniques for portraiture. Once you become familiar with these basic setups, you'll be able to replicate them in and out of the studio and identify their properties whether you're in a restaurant, bedroom, bar, or outdoors. They are provided as a starting point. Once you master these formulas, you will be able to break the rules and sculpt your subjects with more interpretive lighting methods.

The Lights

In portraiture, light sources are generally placed to fulfill a few basic functions. These are: the main light, the fill light, kicker or accent lights, the hair or separation light, and the background light.

Main Light. The main light (also called the key light because it is the principle source of illumination) establishes the basic pattern of highlights and shadows on the subject's face.

Fill Light. The fill light, usually placed to the side of the subject opposite the main light or on axis with the camera, illuminates the entire scene and lightens (or "fills") the shadows created by the main light.

Kicker/Accent Light. The kicker or accent light, an optional addition to the lighting setup, is traditionally placed on the same side of the subject as the main light to highlight particular features of the subject.

Hair/Separation Light. The hair or separation light, if used, is placed above the subject or on the same side as the kicker light.

Background Light. The background light is placed behind the subject to illuminate the background, add separation, and create additional dimension in the image.

Three Basic Main-Light Positions

When photographing portraits, there are essentially three angles at which the main light is placed in relation to the subject, regardless of whether you are

There are essentially three angles at which the main light is placed in relation to the subject.

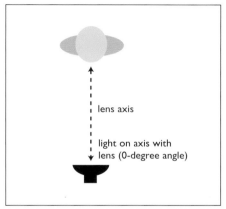

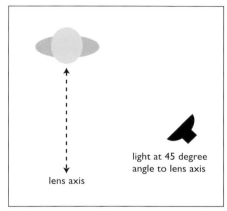

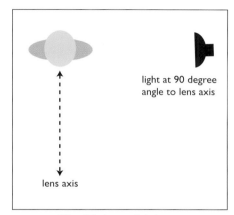

DIAGRAM 11—*Front lighting.*

DIAGRAM 12—*45-degree lighting.*

DIAGRAM 13—*90-degree lighting.*

PLATE 27—*Perry Alarcon contacted me for professional images to start his modeling career. He was running behind schedule and arrived at my studio wearing a short-sleeved white shirt—not the desired clothing for his portfolio. In the past, female models have worn some of my wardrobe, but I didn't have any men's attire available for Perry to borrow. Therefore, I politely asked him if he would mind purchasing a few shirts for our shoot. (Always expect the unexpected and find solutions to unforeseen dilemmas!) Wearing the desired clothing, Perry was first photographed with frontal lighting. As you can see, this does not create a flattering look or much modeling of the subject's face. (ISO 100, 1/60 second, f/4)*

PLATE 28—*For this image of Perry, the main light was placed at a 45-degree angle to the subject's face, creating much better facial modeling. (ISO 100, 1/80 second, f/10)*

PLATE 29—*In this portrait of Perry, moving the main light 90 degrees to camera right created a dramatic split-lighting effect. (ISO 100, 1/80 second, f/10)*

using natural or artificial light. As seen in diagrams 11, 12, and 13, these are: front lighting, 45-degree lighting, and 90-degree lighting.

Front Lighting. Front lighting is often called flat lighting because it produces relatively few dimensional shadows on the face. It is produced when your flash or studio strobe is placed on axis with the camera (at a 0-degree angle). Typically, on-camera flash units produce flat lighting, so this look is sometimes associated with snapshots—not a very professional look. If on-camera flash is all you have to work with, however, there are several portable light design tools, as discussed on page 22, that can help you produce a more pleasing image. (*Note:* It should be mentioned that there *are* ways to produce flattering portraits using front-lighting techniques. Later in this chapter we will learn how to properly execute this type of lighting, called butterfly or Paramount lighting.)

To see the effect of flat lights, look at the image of Perry (plate 27; previous page). This was produced with a Nikon D-200 set on program and a Nikon SB-800 Speedlight set on automatic. As you can see, this technique produced an overall flattening of the planes of his face. Additionally, an unflattering shadow appears behind him. If Perry were moved further from the background, the shadow would fall out of view, but his facial features would still appear flat.

45-Degree Lighting. The most commonly used lighting setup has the main light is placed at a 45-degree angle to one side of the subject. This is quite easy to replicate with a single studio strobe or an off-camera flash. Moving the main light to this angle increases the modeling of your subject's face by creating pleasing shadows that define the facial contours.

With the light in this position, you can adjust the direction of the subject's nose relative to the light to refine the lighting pattern to suit the subject's unique facial features. This will help you accentuate the subject's positive features and diminish the appearance of any facial flaws. This is the key to sculpting a beautiful portrait.

For our next image in this series (plate 28; previous page), Perry was photographed with a Hensel beauty dish attached to a 500W Integra monolight. The light source was placed slightly above the subject and at a 45-degree angle to camera right. The main light was slightly feathered (angled toward the shadow side of the face) to allow a little bit of light to spill over to the shadow side of his face, creating a softer shadow-edge transfer. An Integra 500 with a small softbox attached was placed behind the subject to camera left to illuminate the background. Compare this with the front-lit image of the same subject and note how much more dimensional the subject's face appears.

90-Degree Lighting. When the main light is placed at a 90-degree angle to the subject, the effect is typically called either side lighting or split lighting. Images made with this type of lighting have deep, dramatic shadows that add a lot of character to your model's face. Quite often, I will also place a kicker or accent light at a 90-degree angle in conjunction with a main light to add an accent to the side features of my subject's face.

Continuing on with our examples featuring Perry, the final portrait in this series (plate 29; previous page) was created with the Hensel beauty dish moved to a 90-degree angle from Perry, illuminating only one side of his face. The exposure remained unchanged as the distance of the main light remained the same relative to the subject. The look of the portrait, however, is decidedly dramatic.

Three Views of the Face

The face consists of five planes: two cheeks, nose, forehead, and chin. Collectively, these areas are typically referred to as the "mask" of the face. Just as there are only three main angles in which to place your main light relative to your subject, there are only three positions (poses) in which to properly pho-

Moving the main light to this angle increases the modeling of your subject's face.

Clothing Selection

Here's a good rule of thumb: the darker the skin tone, the lighter the wardrobe (and vice versa). A subject with a dark skin tone will photograph better in lighter clothing, which draws attention to the face. Subjects with lighter skin tones should wear darker colors for the same reason. In both cases, be sure your clients do not wear clothing with bold patterns, flowers, or stripes; this type of wardrobe will distract from their face. You may want to store a variety of tops for men and women in a variety of sizes for your clients to wear for their portrait session. I have actually brought in my own clothing and had clients wear these outfits for their session.

PLATES **30** AND **31**—*Debra wears a lot of black, but this was not the most photogenic color for her portraits. Luckily she brought another outfit, and I politely asked her to change into the lighter color jacket. Notice how the black jacket actually distracts from Debra's facial features, while the lighter jacket draws your attention to her beautifully sculpted face.*

tograph the mask of the face: the three-quarter view, the profile, and the front or straight view.

Three-Quarter View. In the three-quarter view, the subject's face is at an angle to the camera, exposing three-quarters of the mask of the face. The image of Alena (plate 32; next page) is an example of a three-quarter view portrait. It was created for the singer/dancer's portfolio, and our setting was an old train station with graffiti art in the background. A consultation before the session and advance location scouting ensured that the background and clothing choices would be harmonious and artistically pleasing in the photograph. The late afternoon sun provided a nice accent light on Alena's arm,

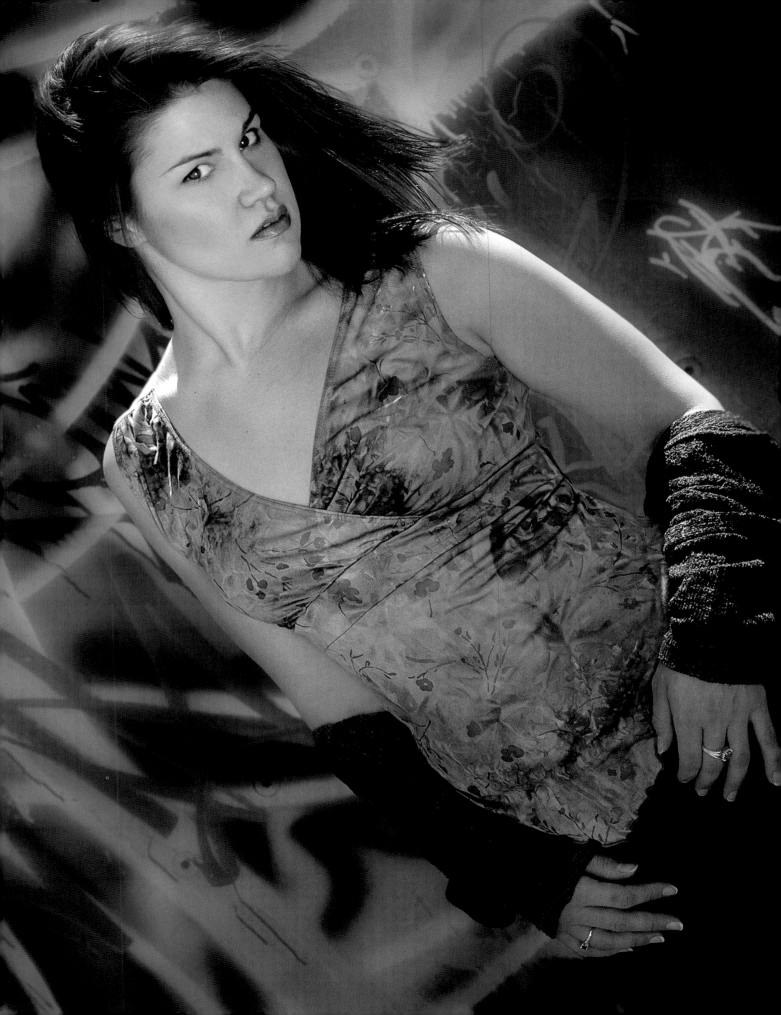

PLATE 32 (FACING PAGE)—*This image of Alena was photographed with the subject's face in the three-quarter view. (ISO 200, $^1/_{100}$ second, f/6.3)*

PLATE 33 (ABOVE)—*This image of Alena was photographed with the subject's face in a profile view. (ISO 80, $^1/_{60}$ second, f/10)*

separating her from the background. To fill the shadows, a 4-foot Mini Sunbounce reflector was added. The reflector chosen was a zebra (gold and silver mix), which added a touch of warmth to her face. For the correct exposures, an incident ambient reading was made at the subject position with the meter facing toward the camera.

Profile View. In the profile view, the subject's face is turned to a 90-degree angle to the camera. This focuses the viewer's attention on only one half of the facial mask, as seen in our second portrait of Alena (plate 33). The image was created with one large softbox positioned to camera left and approximately three feet above the camera. This produced soft, even illumination. Two background lights aimed at a white background and set to record one stop brighter than the main light produced a clean white background. Additional fill was created with a Nikon SB-800 on a camera bracket and a

PLATE **34**—*This image of Alena was pho-
tographed with the subject's face in a front view.
(ISO 100, ¹/₆₀ second, f/4.5)*

Sunbounce reflector to camera left. Some instructors insist a profile include the eyelash of the far eye; I believe this is a matter of personal expression.

Front View. In the front view, the entire facial mask is visible. The front-view portrait of Alena (plate 34) produced a pleasing image with a lot of sass. An ambient reading was made at the model's position with the dome facing the camera. A single California Sunbounce mini zebra reflector placed at a 45-degree angle to the subject bounced a warm glow of light onto her face.

Avoid Mug Shots

When creating a portrait, the subject's eyes and shoulders should never appear on the same plane. To avoid this, ask your model to tilt her head and drop a shoulder to help create interesting angles. This keeps your images from looking like static mug shots.

Short Light vs. Broad Light

In portraiture, you are dealing with human beings and every person has a "good" and "bad" side of their face. By asking your subjects to move their faces from side to side, you will be able to see which side is more photogenic. It is a good idea to not mention you are looking to cover their imperfections; instead, say that you are evaluating how the light shapes their face. Once you determine the "good" side of your subject's face, you can place your main light accordingly.

Short Light. A short-light pattern is created when the main light is placed on the side of the subject's face that is turned away from the camera (the less visible, and thus "short," side of the face). In this setup, the subject's nose is pointed toward the main light. To achieve a pleasing short-light pattern, place your main light high enough to create a shadow below the nose (not too much to the side). Note, however, that subjects with deep-set eyes may require a slightly lower main-light placement to avoid shadowing the hollows of the eyes. Short light patterns work well for subjects with round or heavy faces, provided they are posed in a three-quarter position; it tends to narrow the facial mask, making it appear less heavy and round.

Broad Light. A broad-light pattern is created when the main light is placed on the side of the subject's face that is turned toward the camera (the more visible, and thus "broad," side of the face). In this setup, the subject's nose is pointed away from the main light.

PLATE **35** (LEFT)—*Here, a Hensel Integra 500 monolight attached to a medium softbox was used as the main light. John's head was turned slightly toward the main light, creating highlights on the short side of the face. (Manual mode, ISO 100, $^1/_{125}$ second, f/11)*

PLATE **36** (RIGHT)—*Without moving the main light, I asked John to turn his head away from the main light, thus lighting the "broad" side of his face. A second light was added to illuminate the background and add separation between the background and the shadow side of his face. (Manual mode, ISO 100, $^1/_{125}$ second, f/11)*

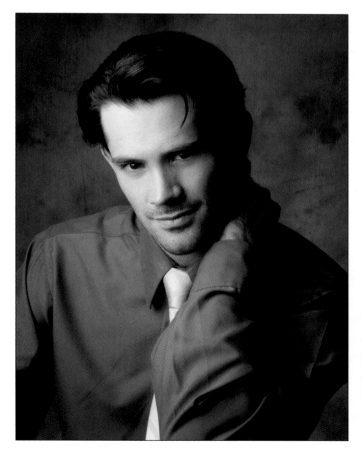

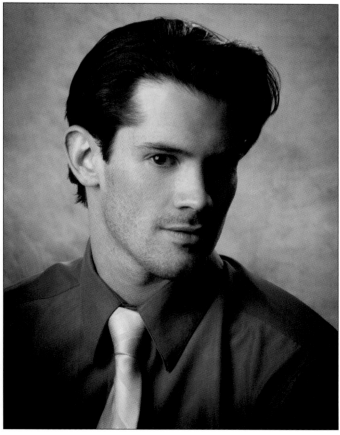

Direction of the Body

Men are usually photographed with their entire body facing the main light while their face and nose are turned the opposite direction. This gives a man a more angular, hard, and masculine appearance. Women's bodies should always be turned away from the main light, regardless of the lighting setup used. By placing a female so that her body is turned away from the main light source, a more feminine portrait is created. When you start paying attention to this one small but important detail, your female clients will tell all their friends how wonderful you made them look, and your business will increase.

Portrait Lighting Patterns

Rembrandt. The Rembrandt light pattern is named for the great Dutch painter, who often painted his subjects with a skylight as his main source of illumination. The pattern is distinguished by an inverted triangular highlight on the shadow side of the face. This is created by placing your main light at a 45-degree angle and directing it down slightly onto your subject. Be sure to set the light high enough relative to your subject so that the shadow of the nose just touches the corner of the mouth. This is what forms the lighted triangle pattern.

You can use this classic lighting pattern successfully with both men and women. Due to the heavy shadows it produces, it thins the faces of heavier

PLATE **37** (LEFT)—*A Hensel beauty dish was attached to an Integra 500 and placed at a 45-degree angle to the subject. Irena's body was turned toward the main light while her nose was pointed away from it. Notice how turning her body toward the main light makes her feminine form appear very angular and broad. This masculine pose is not suitable for photographing your female subjects. (Manual mode, ISO 100, $1/_{100}$ second, f/7.1)*

PLATE **38** (RIGHT)—*Simply turning the model's body away from the main light produces a more pleasing portrayal of the female figure. The shadows add form and creates a feminine rounding and thinning of her overall figure. (Manual mode, ISO 100, $1/_{100}$ second, f/7.1)*

PLATE **39** (FACING PAGE)—*The main light consisted of a Hensel Integra 500 with a medium softbox. To camera left, my main light source was placed at a 45-degree angle to the subject. To achieve the classic triangle pattern, the main light source was placed high and pointed down toward the subject. This created the classic Rembrandt lighting pattern on John's face. Note the triangular highlight on his cheek. (Manual mode, ISO 100, $1/_{125}$ second, f/11)*

subjects and subjects with round faces, making it an ideal lighting pattern to use for these subjects. Additionally, it is ideal for creating mood, depth, and character in your client's face. (*Note:* The Rembrandt pattern can be achieved with either broad or short lighting. It refers to the nose shadow touching the corner of the mouth more than anything else.)

Closed Loop. The closed loop pattern is actually a modified Rembrandt lighting pattern. To achieve it, you place your main light at the same 45-degree angle as for the Rembrandt setup but slightly higher. With the light in this position, the nose casts a rounded shadow that extends down toward the corner of the mouth and connects with the shadow on the cheek.

Open Loop. The open-loop lighting pattern is almost the same as the closed-loop pattern, except that the shadow created by the nose does not

The closed loop pattern is actually a modified Rembrandt lighting pattern.

PLATE **40**—*Keeping my main light source consistent throughout these examples, John was repositioned to obtain a closed loop pattern, I directed John to turn his nose slightly away from the main light source to close the loop on his cheek. (Manual mode, ISO 100, $^1/_{125}$ second, f/11)*

PLATE 41—*Here we see open loop lighting on the broader side of John's face. Using the same main light as in the previous image, I added a small softbox hair light and feathered it slightly toward the camera. This allowed light to spill onto the side of John's face. In this instance, my hair light actually acted as an accent light on John's cheek, adding further depth to this image. (Manual mode, ISO 100, $^1/_{125}$ second, f/11)*

The trick of the open loop is how you place your subject's face and nose relative to the main light.

connect with the shadow on the cheek. Like the closed loop pattern, open loop lighting can originate as a broad- or short-light setup where the main light, at a 45-degree angle to the subject, is placed slightly above camera position and aimed down at the subject. The trick of the open loop is how you place your subject's face and nose relative to the main light.

Loop lighting, both open and closed, is perhaps the most commonly used lighting pattern. Loop lighting is ideal for most every subject you will photograph. On thin faces in particular, loop lighting is ideal for creating a nicely sculpted effect. Loop lighting tends to widen the face, though, so be careful

when using it on subjects with heavier statures or rounder faces. It may make their faces appear heavier than they are. If this is the case, you may want to use only minimal fill to keep keep the shadows deep and maintain as slim a look as possible.

Butterfly. Commonly referred to as Paramount or glamour lighting, this technique was widely used in the headshots of Hollywood actors and actresses of the 1940s and is still very popular in today's fashion magazines. The butterfly lighting pattern is distinguished by the small butterfly-shaped shadow that forms just below the nose when the main light is placed in front of the subject and high above the camera position.

Subjects with large noses are not ideal candidates for this light pattern, as the shadow created by the nose may extend down onto the upper lip and create an undesirable look. Typically, your main light is placed approximately

This technique was widely used in the headshots of Hollywood actors and actresses of the 1940s.

PLATE **42**—*Irena was lit with a soft main light—a beauty dish placed approximately three feet directly above the camera and pointed slightly down onto her face. A monolight with a 20-degree grid was placed at camera right to throw hard light on the model's hair. (Manual mode, ISO 100, $^1/_{100}$ second, f/7.1)*

PLATE **43**—*The main source of illumination for this image of Brian consisted of a medium softbox attached to a Hensel Integra 500 monolight. The softbox was placed high above the camera and aimed onto the subject, creating an undesirable shadow under his nose. (Manual mode, ISO 100, $^1/_{250}$ second, f/7.1)*

Men with mustaches or five-o'clock shadow are not favorable candidates for butterfly lighting.

two feet above the camera. Conversely, in plate 42, the model had a smaller-than-average nose, so the main light had to be placed higher (about three feet above the camera) to produce a distinguishable butterfly pattern under her nose.

Generally, I prefer butterfly lighting for women with petite facial features, though it can be used successfully on men with strong features as well. Men with mustaches or the fashionable five-o'clock shadow are not favorable candidates for butterfly lighting, as the nose shadow may inadvertently merge with the mustache and create an unsightly shadow that extends from the nose to the upper lip.

I have included examples of both a man and a woman so you can be the judge which light looks the best on each. The image of Brian in plate 43 il-

PLATE **44**—*The image of Tiffany Rollins illustrates a typical butterfly light pattern on a female subject. The image was made with a single Hensel Integra 500 monolight attached to a beauty dish placed approximately three feet above the camera. The light appears quite hard, because it was placed at a distance from the subject. (Manual mode, ISO 200, ¹/₁₂₅ second, f/11)*

PLATE **45**—*To soften the effect, a California Sunbounce reflector was placed just under Tiffany's face and pointed up toward her. The reflector added fill in the shadow area around her neck and eye area, as well as another specular highlight to her dark eyes. When photographing subjects with dark eyes, creating a couple of catchlights (reflections from the lights) can help add depth. (Manual mode, ISO 200, ¹/₁₂₅ second, f/11)*

lustrates how the butterfly shadow extends a little too much onto his upper lip and looks somewhat awkward.

The butterfly shadow on the image of Tiffany (plate 44) is also unattractive—it appears quite harsh. Because the butterfly lighting pattern originates from several feet above and points down onto your subject, it is best to always incorporate a reflector underneath your subject to help fill and soften the shadows (plate 45). The reflector adds an extra sparkle to your model's eyes while filling in the shadows under the eye and neck area. For the final portrait of Tiffany in this series, a hair light was added to camera right to complete the effect (plate 46). A strip light was also placed to camera left and slightly behind the subject to enhance the separation on Tiffany's face, and a fan was used to add motion.

Lighting Ratios

Lighting ratios describe the difference between the incident light falling on the highlight side of the subject's face and the incident light falling on the

PLATE **46** (FACING PAGE)—*Keeping the same exposure and lighting position, a hair light was placed to Tiffany's left and adjusted to record one stop brighter than the main light. Subjects with very dark hair will require up to two full stops more light on their hair because the dark color will absorb more light. Subjects with blond hair may only require a half stop more exposure than the main light, as lighter hair reflects more light. Finally, a striplight was placed to camera left and slightly behind the subject to add further definition to Tiffany's face. A household fan was used to add motion and character to this final portrait of Tiffany. (Manual mode, ISO 200, ¹/₁₂₅ second, f/11)*

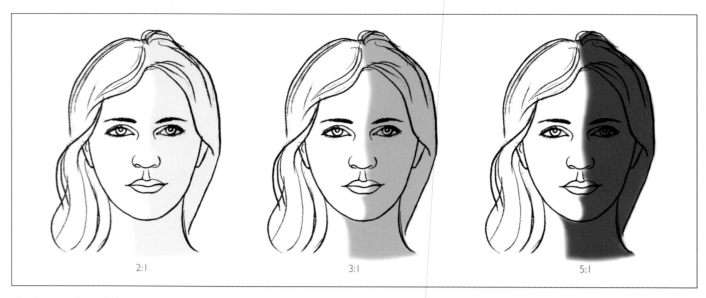

2:1 3:1 5:1

shadow side of the subject's face. The higher the ratio, the greater the contrast—something that has become increasingly important to understand with digital capture.

With black & white film, it was relatively easy to manipulate an image and its contrast in the darkroom. When color film stepped onto the scene, it became imperative for photographers to expose the image perfectly or rely on labs to fix their images—meaning your entire livelihood was at the mercy of an unknown color printer. Digital is even more unforgiving in its exposure, and correcting errors can be quite costly, whether you rely on a trusted printer/retoucher or have to devote your own time to making the adjustments. Therefore, I am of the mindset to get it right in the original capture. This means that I do everything I can during production to ensure minimal post-production. This includes carefully controlling the lighting ratios in my images.

In most cases, you will be placing several layers of light on your subject, but calculating the lighting ratio begins with the fill light. Your fill light is the only light that illuminates the entire scene. This should not, however, be evident in the final photograph, so a low-contrast, non-directional, and non-specular source (such as a large softbox) is an ideal choice. The fill light is often placed at the camera position, or slightly above and behind the camera, to cast an even amount of light over the entire scene.

With the fill light in place, each side of the face receives one unit of light, meaning that the portrait could be described as having a 1:1 ratio, as seen in plate 47 and diagram 14. (*Note:* The amount of fill light on the face does not factor into this calculation; however bright or dim it may be, there is still an equal amount of light on each side of the face.)

After placing the fill light, you can position your main light to produce the particular light pattern desired for your subject. In plate 48, we see Irena, who has a thin face with slight features. This made loop lighting an ideal choice because it tends to widen a thin face. The main light, a Hensel beauty

DIAGRAM 14—*As the light ratio increases (from right to left), the contrast on the subject's face increases.*

Digital is even more unforgiving in its exposure, and correcting errors can be quite costly.

PLATE **47**—*The job of your fill light is to evenly fill the shadows of the entire image. This image of Irena was made with a medium softbox attached to a Hensel Integra 500 and placed approximately three feet above and behind the camera to evenly light the subject. An incident flash meter reading was made at the subject position. With my meter pointed toward the camera, the exposure recorded was f/5. (Manual mode, ISO 200, $^1/_{125}$ second, f/5)*

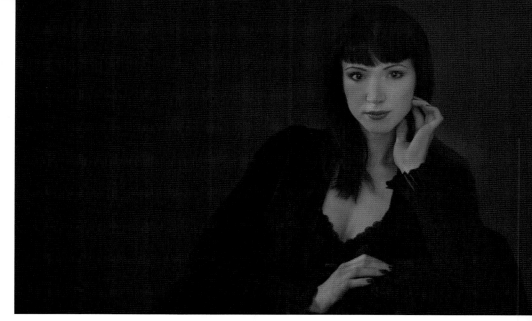

PLATE **48**—*A beauty dish was added to camera left as the main light for this loop-lit portrait. (Manual mode, ISO 200, $^1/_{125}$ second, f/8)*

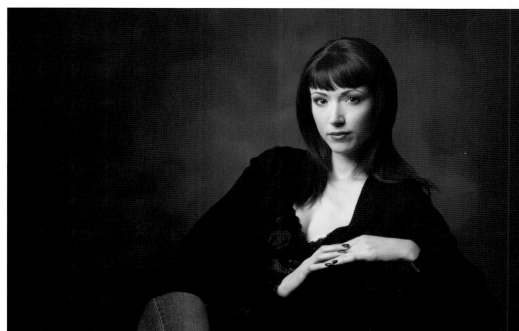

PLATE **49**—*The addition of a hair light completes this portrait and adds a little accent on the subject's shadow side. (Manual mode, ISO 200, $^1/_{125}$ second, f/8)*

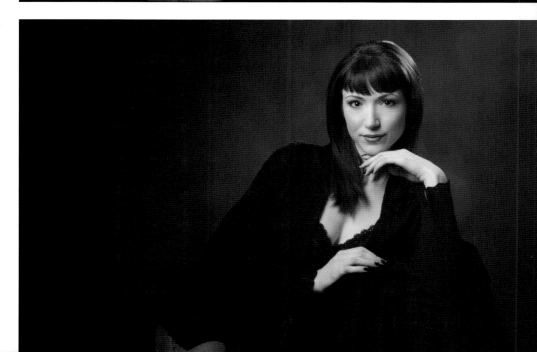

dish, was placed to camera left at a 45-degree angle to the subject. Next, I recorded the exposure of the main light with an incident meter reading. With my flash meter pointing toward the main light source and the fill light turned off, I recorded an exposure of f/8, or one stop brighter than the fill light.

Now, let's calculate the lighting ratio. To do this, we consider the difference between the fill-light and the main-light readings. For each stop of difference, two units of light are added. In this case, the main light is one stop brighter than the fill light. With only the fill light in place, as noted on page 51, the lighting ratio was 1:1 (one unit of light fell on each side of the face). By adding the main light, we have added two units of light (one stop) on the highlight side of the face. No light has been added to the shadow side of the face. This means that the ratio is now 3:1. The highlight side receives three units of light (one from the fill light, two from the main light), while the shadow side of the face receives one unit of light (from the fill light).

Imagine that the intensity of the main light was reduced so that it was only half a stop brighter than the fill light. In this case, the main light would add one unit of light (half a stop) to the highlight side of the face. Therefore, the highlight side would receive a total of two units of light (one from the fill light, one from the main light), while the shadow side of the face received one unit of light (from the fill light). The resulting light ratio would be 2:1.

Ratios are useful because they describe how much local contrast there will be in the portrait—something that, as noted previously, is extremely important to consider with digital capture. The ratio is also an indication of how much shadow detail and shaping you will have in the final portrait. For example, a 2:1 ratio reveals only minimal roundness in the face. A 3:1 lighting ratio shows good shaping and is a common choice in portraiture. A 5:1 ratio provides very minimal shadow detail—a dramatic effect.

Note that the addition of other lights, such as hair or accent lights, does not change the lighting ratio, as these lights do not illuminate the facial features. For example, in plate 49, a hair light was added (a Hensel Integra 500 with a small softbox attached). The hair light was intentionally feathered away from the background, so when the model turned her face slightly away from the main light, it created a gentle accent in the shadow area of the image.

High Key or Low Key

High Key. High-key portraits typically feature a clean white background and gentle shadows on the subject's face. Diagram 15 illustrates the light placement of a typical high-key portrait light setup that includes two backlights. The backlights must be set one to two stops brighter than the main light to ensure a pure white background. Keep in mind that a high-key portrait does not mean a flatly lit photograph. Be sure to incorporate accent and kicker lights from a hard light

Ratios are useful because they describe how much local contrast there will be in the portrait.

DIAGRAM 15—*A typical high-key lighting setup.*

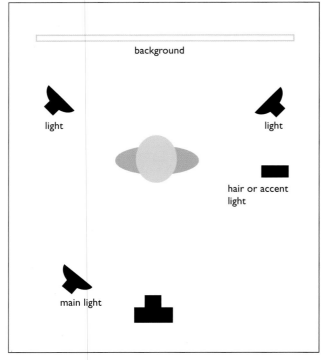

PLATE **50** (LEFT)—*This is a nicely lit high-key portrait, but it lacks a sense of depth. (Manual mode, ISO 200, ¹/₁₆₀ second, f/16)*

PLATE **51** (RIGHT)—*The addition of an accent light to camera right added dimensional highlights to the image. (Manual mode, ISO 200, ¹/₁₆₀ second, f/16)*

source to add specular accents on the subject. These should be set 1½ stops brighter than the background to ensure proper separation and sculpting.

Let's look at an example. Plate 50 is an image of Jackie Stone that was created for the teen's high-school yearbook. Jackie's portrait was made using a typical high-key lighting setup. The main light was placed approximately three feet above the camera and angled down toward the subject to produce a soft butterfly pattern. No fill was used. Two Hensel Integra 500 monolights were placed on either side of the white background and their intensity was adjusted to record one stop brighter than the main light source. The image is nicely lit, although it lacks a sense of depth—it actually looks flat.

Without moving the existing lights or changing the camera settings, a monolight with a 20-degree grid was placed to camera right as an accent light (plate 51). This was adjusted so that it recorded at 1½ stops more exposure than the main light. Had the accent light been adjusted to produce only one stop more exposure, it would have blended into the background. The extra increase in exposure ensured the light on Jackie's cheek would stand out to create depth in the image.

Low Key. Low-key portraits typically feature a dark background and deeper, more dramatic shadowing on the subject's face. Diagram 13 illustrates a traditional lighting design for a low-key portrait. The main light is placed at a 45-degree angle to the subject, and its placement will dictate the direction in which the other lights are placed. If the main light is placed at camera right, the remaining lights will be placed in a counterclockwise arrangement from camera position. Essentially, the lights "wrap" around the subject—almost as if the light were coming from one light source. The diagram may be a bit overwhelming—but trust me, you don't have to go out and purchase a lighting setup with five lights. Beautiful low-key images can be successfully made with a two- or three-light setup and reflectors.

Perry, shown in plate 52, was photographed using a traditional low-key lighting setup. The main light was placed at a 45-degree angle to the subject at camera right. To add dimension, a kicker light was placed at approximately a 90 degree angle to the subject, also at camera right. This created a specular highlight on Perry's left cheek while highlighting his hair. A third light was placed to camera left. This acted as a background light while illuminating his right cheek. The final image is a beautiful rendition of a man whose portrait shows great depth.

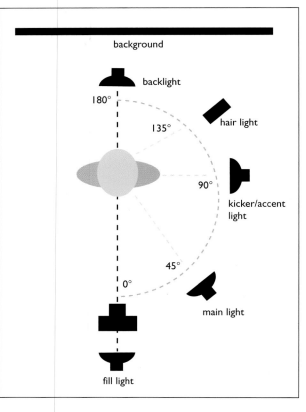

DIAGRAM 16—*A typical low-key lighting setup.*

PLATE 52 (FACING PAGE)—*With three lights, it's simple to create an effective low-key portrait. (Manual mode, ISO 100, $^1/_{160}$ second, f/16)*

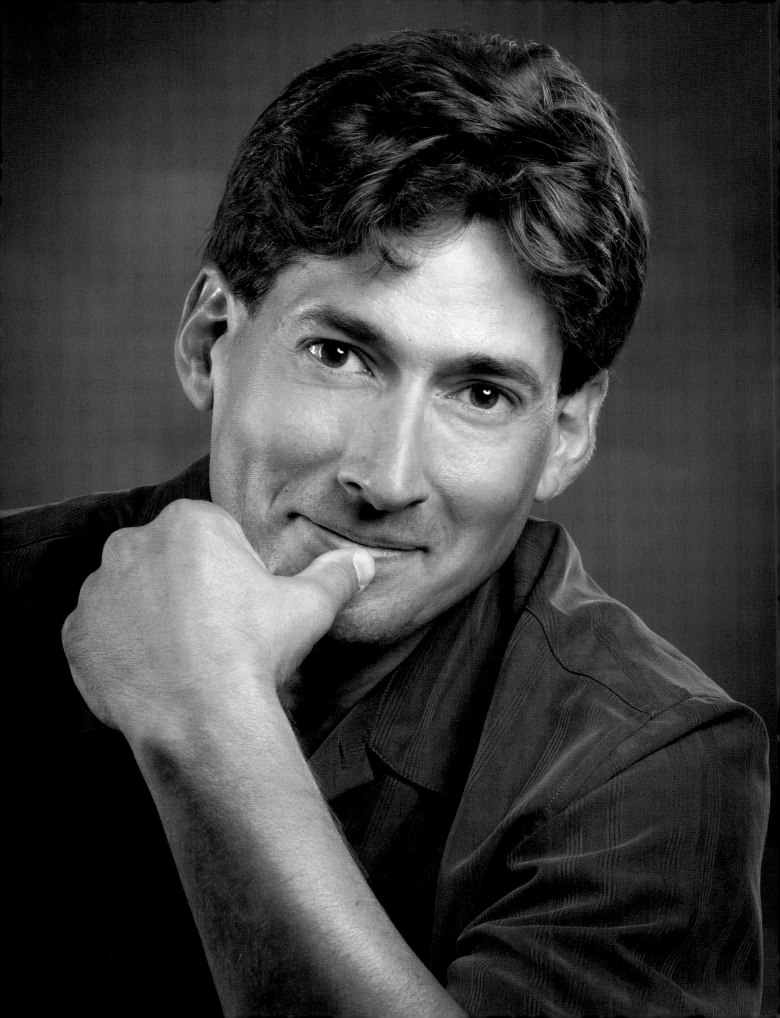

5. Lighting Different Facial Shapes

Though there are literally dozens of different facial shapes, I have limited the examples to the most common face shapes: round, oval, rectangle, angular (long), square, and triangle (heart). The examples presented in this chapter will give you a base from which all facial masks can be deciphered to determine which lighting will work best for the given subject, male or female. Keep in mind these examples are "perfect" representations of facial shapes; your everyday client will not likely possess a perfectly shaped face, so be prepared to blend approaches and improvise to create a tailored look that emphasizes their unique assets and downplays any flaws.

A round face is perhaps the most common facial mask portrait photographers will encounter.

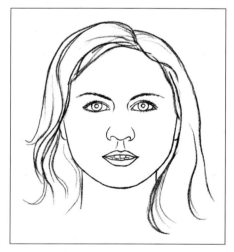

DIAGRAM 17—*Round face.*

Round Faces

A round face is perhaps the most common facial mask portrait photographers will encounter, and it can derive from any of the facial shapes mentioned above. Subjects with extra weight on their frame typically will have extra weight on their facial mask, thus making an oval, square, or triangle face appear more round. Regardless of the origin of the round facial mask, your job is to photograph each subject in his or her best light. Therefore, the ideal lighting setups for clients with round faces help to slim their appearance. They are typically Rembrandt-, loop-, and split-lighting setups. Butterfly lighting is not recommended for round faces, as it will widen the facial mask and make your subject look heavy.

Sculpting Lighter Complexions with Shadows. Shanee' Patallas (plate 53) is a slender, stunning young lady who happens to have very round features. As a result, producing a flattering portrait required creating shadows on either side of her face to add shape and depth on her apple cheeks. A modified lighting setup with the main light placed at an angle between 45- and 90-

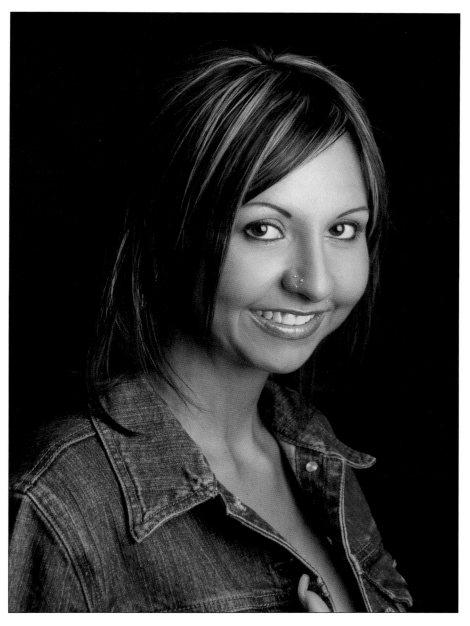

As you move the subject, you will see their face change, creating a variety of different looks.

degrees to the subject was used. Throughout this series, the main light was a single Hensel Integra 500 monolight with a medium softbox attached. This produced a soft shadow-edge transfer.

In most cases, it is preferable to leave your main light source where it is and reposition your subject relative to the light. As you move the subject, you will see their face change, creating a variety of different looks. Without moving my main light source from its position in the previous image, Shanee' was directed to tilt her head to the right, which made a significant difference in the shape of her facial features, especially her left cheek (plate 54). Because of the change in position, her right cheek also received less illumination from the main light source, enhancing the sculpting effect on her face. Notice, however, that while her body is still positioned facing the main light, the focus is now more on her face and less on her body.

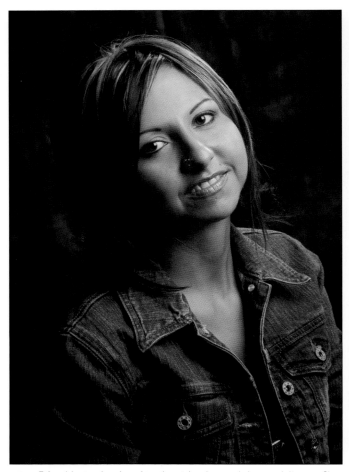

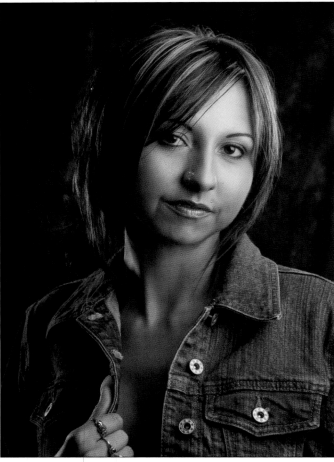

PLATE 54—*Moving her head to the right changed the modeling on Shanee's face. Notice that her body is still turned toward the main light. (Manual mode, ISO 100, ¹/₁₂₅ second, f/7.1)*

PLATE 55—*Having Shanee' turn her body away from the main light created a more feminine look. An accent light was also added at camera right. (Manual mode, ISO 100, ¹/₁₂₅ second, f/7.1)*

In the next image (plate 55), Shanee' was asked to turn her body away from the main light source, creating a more feminine effect and thinning her body. Take a moment to compare this image with the previous one. Can you see the difference? In this pose, she automatically tilted her head to the left, making for a pleasing portrait. To create extra depth in Shanee's portrait, an accent light (an Integra 500 with a softbox) was placed slightly behind her to camera right. This illuminated her hair and added depth to the left side of her body. The accent light was metered and adjusted to record approximately three-quarters of a stop lighter than the main light, producing nice separation from the background and accenting the model's hair.

To create optimal shaping of Shanee's round face, I used accent lights, head and body placement, and careful shadowing to help make the final images for her portfolio. For the next-to-last image of Shanee' in this series (plate 56), the main light was moved approximately 10 degrees to the left of its original position. A second accent/hair light was also placed slightly behind the model to camera left to create this beautiful three-dimensional fashion portrait for her portfolio. Notice how the accent lights produced nice separation on her arm and hip. Additionally, shooting with a telephoto lens al-

In this pose, she automatically tilted her head to the left, making for a pleasing portrait.

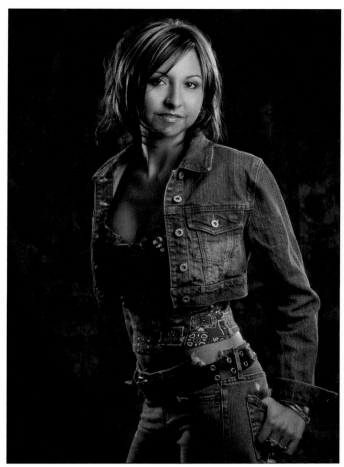

PLATE 56—*The main light was moved ten degrees to the left and an additional accent light was added to camera left to create this flattering image for Shanee's portfolio. (Manual mode, ISO 100, ¹/₁₂₅ second, f/7.1)*

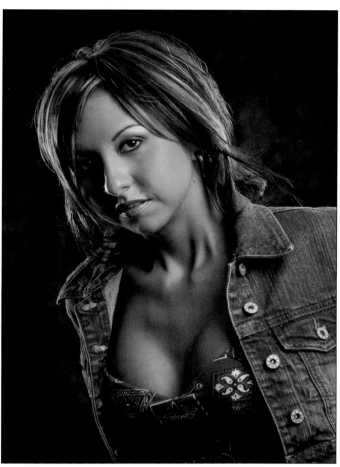

PLATE 57—*Tilting her head to camera left created a split-lighting pattern on her face—without any change in the lighting setup. (Manual mode, ISO 100, ¹/₁₂₅ second, f/7.1)*

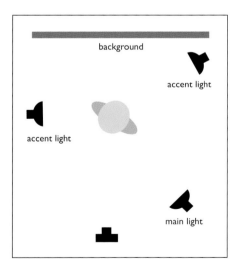

DIAGRAM 18—*The lighting setup for plate 56.*

lowed me to change the composition and produce a pleasing three-quarter-length body shot for her portfolio.

To create a different look with the same final lighting setup (plate 57), Shanee' tilted her head to her right, creating a beautiful split-lighting pattern on her face. A 70–200mm lens was used at maximum extension to compress the background and throw it out of focus, forcing the viewer's attention on the dramatic lighting pattern on Shanee's face.

___**Sculpting Darker Complexions with Highlights.** The next series of photographs illustrates the challenge of photographing and sculpting a person with a round face and a dark skin tone. When you photograph subjects with dark complexions, it helps to accentuate and highlight their facial features if you incorporate additional accent lights adjusted brighter than your main light. Remember that dark tones absorb more light, thus you may need to increase your exposure by one stop or more from what is measured by your meter.

The first portrait of Debra Draughon, shown in plate 58 (next page), was made with a Hensel Integra 500 monolight fitted with a 20-inch beauty dish that was placed four feet above the camera to produce a butterfly lighting

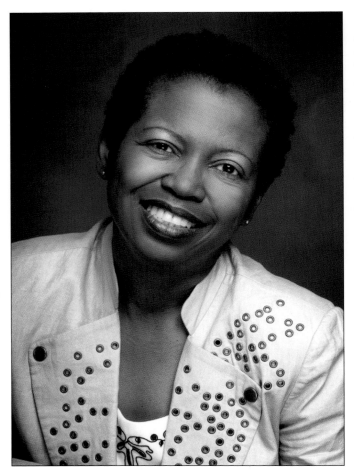 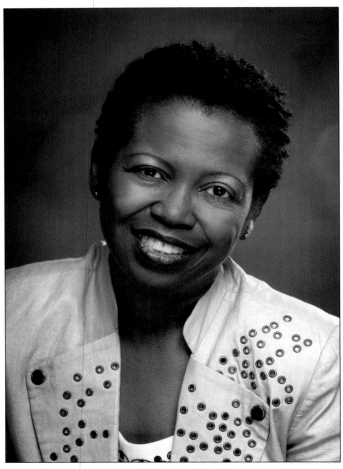

PLATE **58**—*This portrait of Debra was made with the main light, a beauty dish, placed four feet above the camera and a reflector below the subject's face. (Manual mode, ISO 100, ¹/₂₅₀ second, f/5.6)*

PLATE **59**—*Here, an accent light was added to camera right. (Manual mode, ISO 100, ¹/₂₅₀ second, f/7.1)*

pattern. Though Debra has a round face, the butterfly lighting helped to widen her relatively thin features. An incident exposure reading was made at the subject position, recording an f-stop of f/8. The camera, however, was set at f/5.6 (one stop brighter than measured) to properly record her dark skin tone. To add sparkle in her dark brown eyes, a California Sunbounce reflector was placed under the model's chin to add a specular catchlight.

Without moving the main light, an additional accent light was placed to camera right to add a specular highlight on Debra's cheek (plate 59). The accent light consisted of a small strip softbox that was adjusted to produce 1.5 stops more light than the main light. In plate 60, notice how redirecting Debra's pose (without any change in the lighting) produced a more prominent shadow on her right cheek and a brighter specular highlight on the left side of her face. This is a pleasing executive portrait for this Air Force Reserve Officer.

In plate 61, I kept the same main and accent light as in the previous images, but another accent light was placed to camera left. This created nice sculpting and dimension for a beautiful formal feminine portrait.

Without moving the main light, an additional accent light was placed to camera right . . .

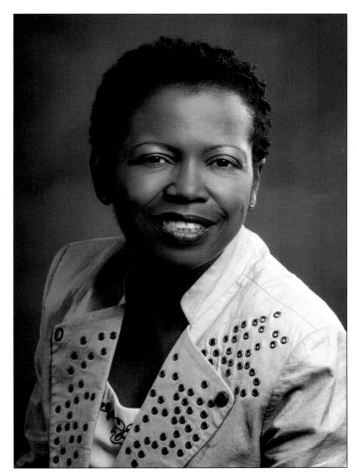

PLATE 60—*Changing the pose, with no change in the lighting setup, yields an entirely different look. (Manual mode, ISO 100, ¹/₂₅₀ second, f/7.1)*

PLATE 61—*Adding a second accent light to camera left completed this pleasing formal portrait. (Manual mode, ISO 100, ¹/₂₅₀ second, f/7.1)*

DIAGRAM 19—*Oval face.*

Oval Faces

The oval-shaped face is perhaps the most symmetrical and easiest to photograph. If you look at magazines with female models you will see an abundance of oval face shapes, because they are quite photogenic and can be lit in all types of setups and patterns with great success. Typically, oval faces are thin, so they will not benefit from Rembrandt lighting or any other lighting setup designed to slim the face. Instead, broad lighting—especially with Paramount- and loop-lighting setups—works beautifully with oval-faced subjects. Of course, your average client with an oval face may have imperfections, such as extra weight on the face or neck area. If your subject has any features that would look best diminished, place them in the shadow areas of the portrait.

Accenting Natural Beauty. The next series of images features Amanda Enloe, a model with no noticeable flaws. Therefore, these examples show how to accentuate a subject's natural beauty and features by incorporating additional lights and reflector techniques.

The first set of images illustrates the effects of a 45-degree light setup that creates soft loop lighting. Starting with one main light, I progressively added light sources and reflectors to create classic portraits of Amanda.

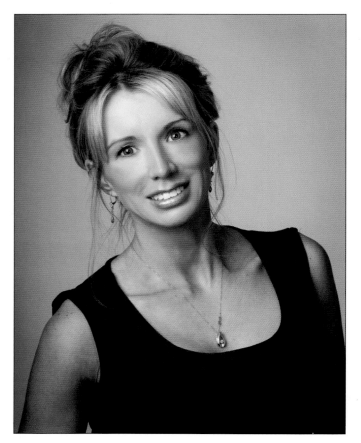

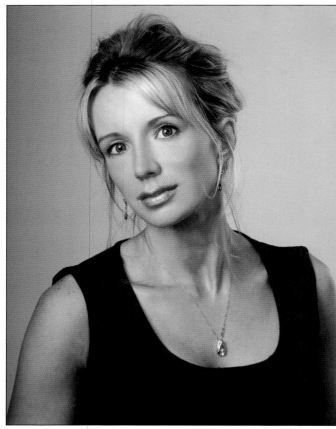

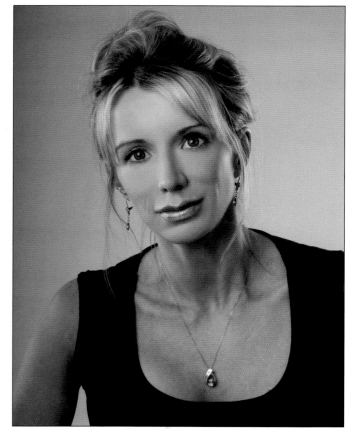

PLATE 62 (TOP LEFT)—*Amanda was lit with a softbox placed at a 45-degree angle to the subject at camera left. (Manual mode, ISO 100, ¹/₂₅₀ second, f/8)*

PLATE 63 (TOP RIGHT)—*Amanda turned her face more toward the main light. A reflector was also added to camera right. (Manual mode, ISO 100, ¹/₂₅₀ second, f/8)*

PLATE 64 (LEFT)—*An accent light was added to camera right, creating the highlight on the model's left cheek. The highlight on her right cheek was from the original backlight, which was feathered toward her. (Manual mode, ISO 100, ¹/₂₅₀ second, f/11)*

An incident meter reading was made at the subject position ...

In plate 62, Amanda was illuminated with a single Hensel Integra 500 with a medium softbox placed at a 45-degree angle to the subject at camera left. An incident meter reading was made at the subject position with meter's dome facing the main light. The recorded exposure of f/8 was set on the camera while the shutter speed was set at $\frac{1}{250}$ second at ISO 100. The model was directed to tilt her head slightly and turn her nose away from the main light source to produce an open loop pattern on her face. The white background was lit with a 7-inch parabolic reflector attached to a monolight. The intensity of the light was adjusted to record at f/5.6 (one stop less exposure than the main light). This kept the background a denser shade of gray.

Without moving the main light or changing the exposure settings on the camera, I asked Amanda to turn her nose slightly toward the main light, which brought her left cheek out of shadow (plate 63). A second monolight

Try Handholding

When your camera is secured to a tripod, your images will automatically look uniform. However, a tripod can be restrictive and unnecessary when using strobes, because the exposure is controlled by the f-stop. Try hand-holding your camera and use a variety of lenses and focal lengths and you will start to see your images and subjects more creatively. Using a high shutter speed of $\frac{1}{250}$ second allows me to confidently handhold a 70–200mm lens (refer to your camera's manual as to the highest shutter speed you can use and still keep synced with your flash unit).

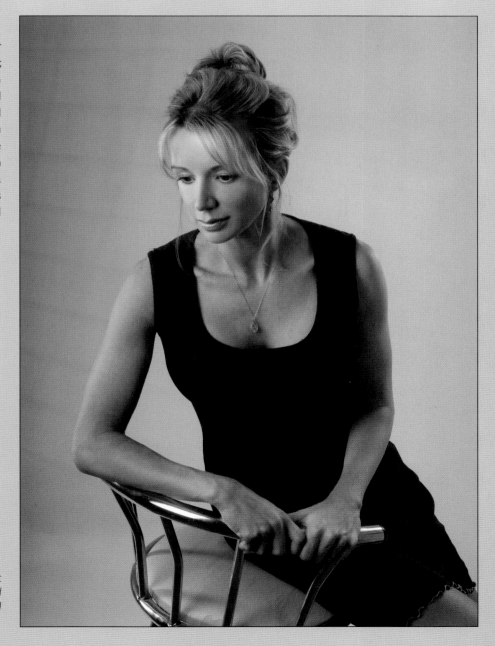

PLATE **65**—Here, I used a wider focal length and shot down onto Amanda to create a very different feel and perspective of this beautiful young lady. (Manual mode, ISO 100, $\frac{1}{250}$ second, f11)

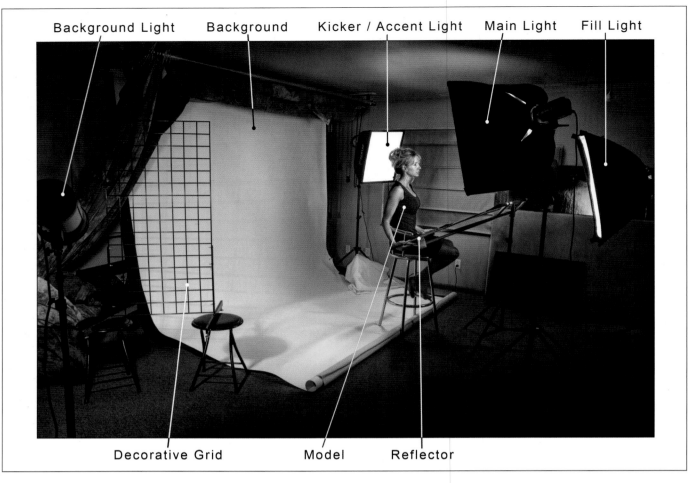

Background Light · Background · Kicker / Accent Light · Main Light · Fill Light

Decorative Grid · Model · Reflector

with a small softbox attached was placed behind the subject to camera right to slightly illuminate the background. The backlight exposure was adjusted to record half a stop brighter than the main light. To ensure the background received no additional illumination from the backlight, the softbox was "feathered" away from the background to retain the exposure and gray color of background. Finally, to add a slight fill and sparkle to Amanda's eyes, a mini zebra California Sunbounce reflector was placed to camera right.

For plate 64 (page 62), a third light (a monolight with a small strip light attached) was added to camera right at approximately a 75 degree angle to the subject. This added a beautiful specular highlight that accentuated Amanda's left cheek. The exposure of the accent light was set three-quarters of a stop brighter than the main light. The highlight on the model's right cheek was from the original backlight, which was feathered toward the model to create further specularity and dimension.

The beautiful high-fashion image seen in plate 66 was created by turning off the background light and adding a reflector. A 4-foot mini zebra California Sunbounce reflector was positioned under Amanda's face to brighten her eyes.

In plate 67, you can see the variety of lights and their placement used to create the series of images of Amanda. Without ever moving the main light,

PLATE 66 (FACING PAGE)—*The backlight was turned off and a reflector was added under the model's face to brighten her eyes. (Manual mode, ISO 100, ¹/₂₅₀ second, f/8)*

PLATE 67 (ABOVE)—*The lighting setup used to create these portraits of Amanda.*

creating a series of different looks was as easy as adding a light or reflector, redirecting the subject, or merely turning off a light. Notice that Amanda is actually holding the reflector—by all means, don't be afraid to ask your clients for help. They will almost always be excited to be included in the creative process.

Slimming Oval Faces. In the next series of illustrations, we'll look at how to use subtractive lighting to create slimming shadows on an oval-faced subject with a little extra weight on her facial mask. Leslie Abeyta was photographed in a makeshift outdoor studio (a huge light tent) provided by Digital Labrador in Kansas City, MO. The tent was made of white rip-stop nylon attached to portable stands. This provided an even source of illumination that allowed an enormous amount of diffused light to bounce around the subject. This white rip-stop nylon can be purchased at most fabric outlets and is the same material used on studio softboxes to scatter and diffuse the light for a softer effect.

The first example of Leslie (plate 68) shows an available-light situation inside the outdoor studio. An ambient incident-meter reading was made from the subject position with the meter pointing toward the camera. An exposure of $1/160$ second at f/9 was recorded, and my camera was set manually to ensure that Leslie's shirt would record black and the white background would record white. Remember: An incident meter reads the light falling onto the

Your clients will almost always be excited to be included in the creative process.

PLATE **68** (LEFT)—*The lighting here is flat, resulting in a non-dimensional look. (Manual mode, ISO 200, $1/160$ second, f/9)*

PLATE **69** (RIGHT)—*Butterfly lighting was created with a beauty dish. The look is better, but her left cheek appears a bit heavy. (Manual mode, ISO 200, $1/160$ second, f/9)*

subject and renders the image more accurately in terms of color and density. Though a nice image, the lighting appears flat and non-dimensional.

Progressing toward a beautiful sculpted portrait, plate 69 was made with a single monolight fitted with a beauty dish. The light was placed to create a butterfly lighting pattern (see page 46). Notice the slight shadowing that appears on Leslie's cheekbones; unfortunately, the position of her head makes her left cheek appear a bit heavy.

Asking Leslie to tilt her head slightly to the right and turn her nose away from the main light reshaped her cheeks, restoring their normal proportions (plate 70). Without moving the main light, the light pattern on her face became an open loop pattern, giving more shape to her facial mask. To further sculpt Leslie's facial features, a gobo was introduced to camera left to block (subtract) the light reflected from the opening on the lighting tent. This added depth to the right side of her face.

In the previous image (plate 70), the gobo blocked too much light from Leslie's right eye. To solve this problem, in plate 71 the gobo was moved slightly closer to the camera, allowing a small amount of reflected light to highlight her cheek area and brighten her right eye. Had the gobo been completely removed, the slight sculpting shadow on her cheek would have disappeared and her cheek would have been washed out. The finishing touch was placing a silver reflector under Leslie's chin, which bounced ambient light

Without moving the main light, the light pattern on her face became an open loop pattern …

PLATE 70 (LEFT)—*Changing the subject's pose slightly and adding a gobo to camera left created more flattering sculpting of the facial mask. (Manual mode, ISO 200, $^1/_{160}$ second, f/9)*

PLATE 71 (RIGHT)—*Adjusting the placement of the gobo and adding a reflector beneath the subject's face completed the lighting setup for this attractive image. (Manual mode, ISO 200, $^1/_{160}$ second, f/9)*

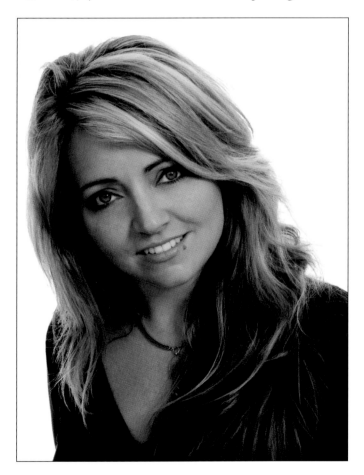

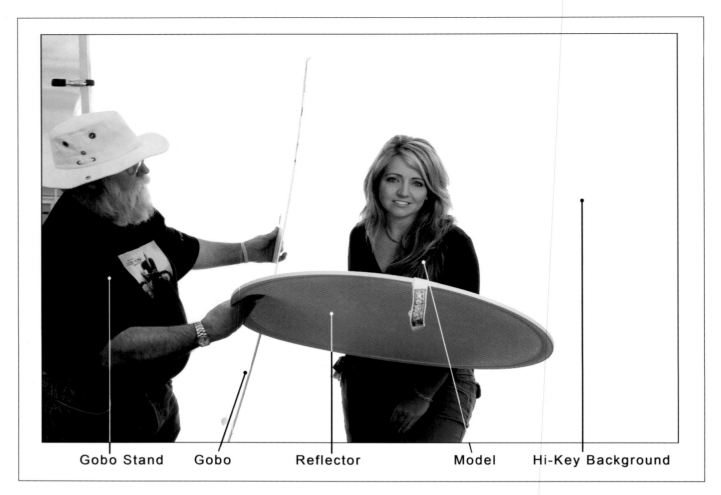

| Gobo Stand | Gobo | Reflector | Model | Hi-Key Background |

back to fill the underside of her eyes and chin area. With the main light exposure set at f/9, a bare-bulb light measuring one stop brighter than the main light was placed outside the portable studio and behind the subject to ensure a pure white background.

Rectangular Faces

Rectangular faces come in many different variations, so they are not always easy to distinguish. In all cases, however, the lighting designs that work best when photographing this type of facial shape include: modified Rembrandt, loop, and butterfly (if executed correctly with light-subtracting techniques).

Open-Loop Lighting. The following illustrations of M'shell Lopez show a classic full-length portrait that accents the facial mask as well as the dress. The open-loop style demonstrated here is easy to replicate for events such as proms, weddings, and formal balls, where a little extra time placing lights will make beautiful portraits with feeling and depth—and increase sales. If photographing subjects with extra weight, the lighting can be modified to increase the amount of shadow effect, either by eliminating the fill light or reducing its intensity relative to the main light.

To create plate 73, a single medium softbox was attached to a 500W Hensel Integra monolight set to full power. The light was placed on axis with

PLATE **72**—*Though the main light, a beauty dish, is not visible in this set scene, you can get the idea of the placement of the reflector under Leslie's face and the gobo relative to the subject. Frank Hamilton from Digital Labrador was gracious to assist on this shoot.*

DIAGRAM **20**—*Rectangular face.*

A Low Angle for Full-Lengths

When photographing full-length portraits, it is best to place the camera slightly below the subject's waist level to ensure that they look will proportional (or even a little taller) in the final image. If your camera is placed at eye level with the subject, they will appear "squatty" and short.

the camera and approximately seven feet away from the subject to ensure proper exposure coverage of the entire face and body. An incident exposure reading recorded f/11. The main point of interest was M'shell's face, so the main light was elevated to two feet above the height of the subject, putting it at a 45-degree angle aimed down toward the subject. M'shell's body was turned away from the main-light source to enhance her feminine frame; her face and nose were turned slightly toward the camera, creating a soft yet defined open-loop pattern. (*Note:* I selected a telephoto lens for this image to compress the model and separate the background by throwing it out of focus relative to the subject. Both effects are inherent features of telephoto lenses.)

In plate 74, the main-light source and exposure remained the same, but a 20-degree grid was placed over a Hensel Integra 500 monolight and positioned to add strong directional hair/separation lighting. Since M'shell has dark hair, this light was adjusted to record an exposure of one f-stop lighter than the main light (f/16), ensuring adequate separation from the back-

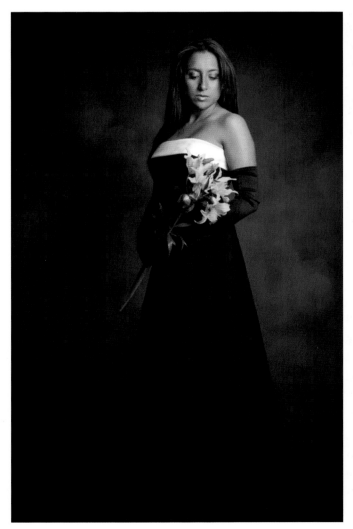

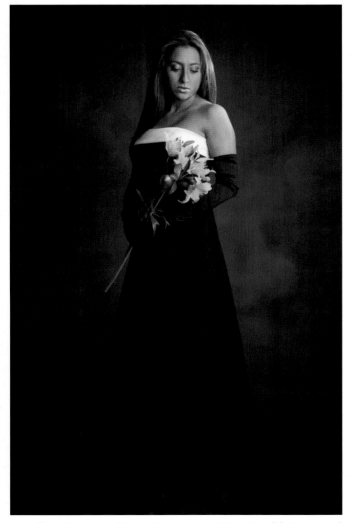

PLATE **73**—*The main light, placed on axis with the camera and seven feet from the subject, was angled down toward the subject. (Manual mode, ISO 200, $^1/_{125}$ second , f/11)*

PLATE **74**—*A hair light (Hensel Integra monolight with a 20-degree grid) was added to create separation. (Manual mode, ISO 200, $^1/_{125}$ second, f/11)*

ground. If M'shell had blond hair, the required exposure would have only been half a stop above the main-light setting.

To change the feel of the portrait from that seen in plate 74, the hair light was changed. In plate 75, the grid that produced a hard, directional light was replaced with a small softbox, creating a softer feeling.

Note that, so far, I have elected not to use a fill light in this series. This helped retain the classic sculpting of her face. If I desired to show more detail in the dress, however, a fill light could have been placed to camera left, low enough to illuminate only the bottom portion of the dress. Since the dress is black and will absorb a lot of light, the fill light would need to be set at least one stop brighter than the main light. If you were photographing a bride in

Note that, so far, I have elected not to use a fill light in this series.

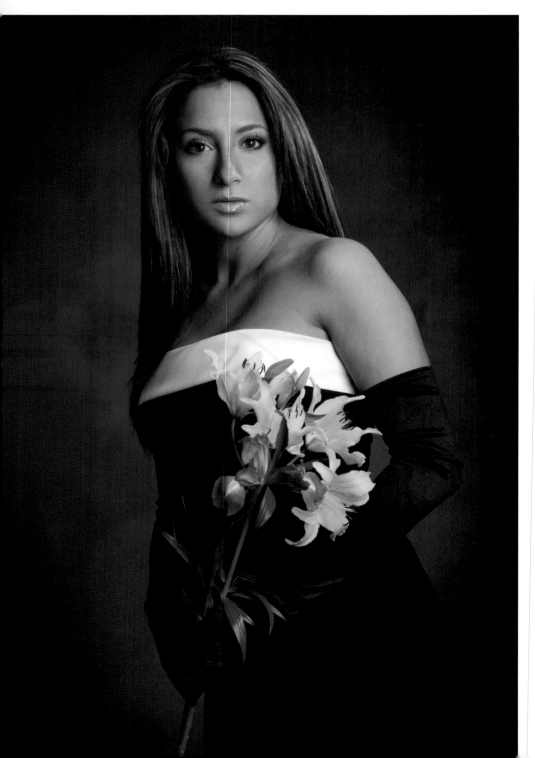

PLATE **75**—*For a softer look, the hair light was switched to a small softbox. (Manual mode, ISO 200, $^1/_{125}$ second, f/11)*

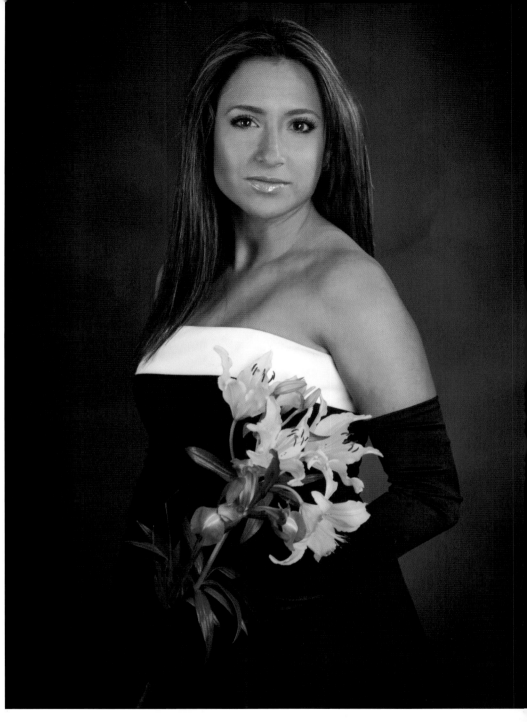

If the fill light was equal to the main light, the images would appear flat.

a white dress, however, the fill light would need to be set at least half a stop lower than the main light. A common mistake when lighting a bride in white is to place the main and fill at equal intensities. This will produce a flatly lit portrait that lacks dimension.

For the final image of M'shell (plate 76), let's look at the effect of adding fill light. To create this image, a strip light was placed 90-degrees to camera left. To maintain the dimensional look, the fill light was adjusted to record at half a stop less than the main light. If the fill light was equal to the main light, the images would appear flat. There would be no distinct shadowing on the facial features.

Butterfly Lighting. Rectangular faces can also be successfully lit using butterfly lighting. You may have noticed that traditional light ratios and light placement have not been used throughout the series on lighting different facial masks. The light techniques are more interpretive lighting, which means the light is placed to suit each individual subject.

In plate 77, M'shell was photographed with a Hensel Integra 500 monolight fitted with a beauty dish as the main source of illumination. This was positioned two feet above the camera and pointed down toward the model's face, producing a soft butterfly shadow under her nose. With the camera set on manual, an incident-light exposure reading was made, indicating an aperture of f/11. The white background received no additional illumination, thus rendering it as gray.

Plate 78 was made without changing my main light position or exposure. The change we see was created by adding a strip light approximately 70-degrees to camera left. Used for fill light, this was set to record an exposure half as bright as the main light. Two additional lights were also added: a back-

The white background received no additional illumination, thus rendering it as gray.

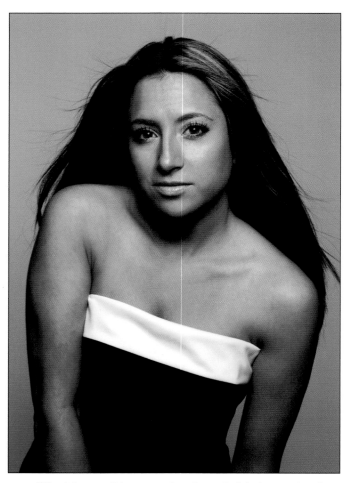

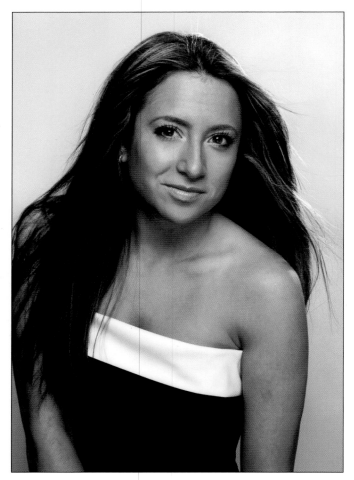

PLATE **77**—*A beauty dish was used as the main light. It was placed two feet above the camera and directed down toward the model's face. (Manual mode, ISO 200, ¹/₁₂₅ second, f/11)*

PLATE **78**—*Several lights were added to create this final portrait. For fill, a strip light was added to camera left. A hair light was added behind the subject to camera right. To light up the eyes, a reflector was placed below the model's face. Finally, a gobo was placed close to the model's left side to sculpt her cheek. (Manual mode, ISO 200, ¹/₁₂₅ second, f/11)*

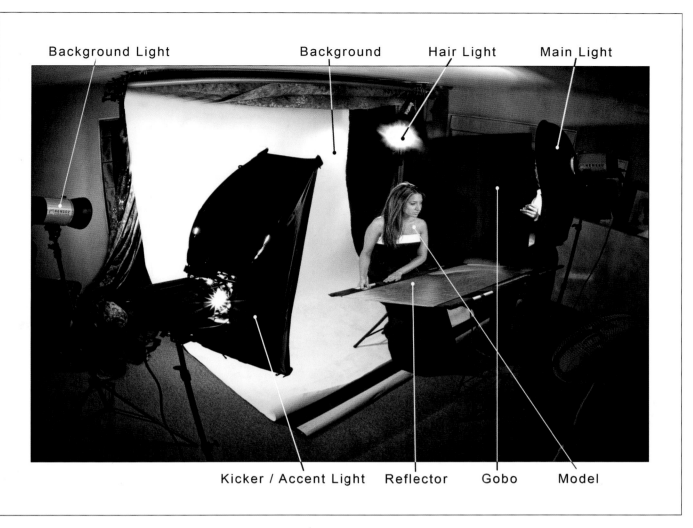

Background Light Background Hair Light Main Light

Kicker / Accent Light Reflector Gobo Model

PLATE 79—*Here you can see the exact setup that was used to produce the final image of M'Shell. The gobo consisted of a black presentation board purchased at a local craft store. Remember, the choice of equipment doesn't have to be expensive, just effective. (Manual mode, ISO 200, ¹/₁₂₅ second, f/11)*

ground light and a hair light. The background light was aimed toward the white background paper and adjusted to record an exposure of f/16—one stop brighter than the main light. This rendered the background its actual color, white. The hair light was fitted with a grid to ensure hard separation. This light was positioned behind the subject to camera right and set to f/16. To add sparkle to M'shell's eyes, a California Sunbounce zebra reflector was also positioned just under the model's face, and a gobo was placed close to the model's left side to block any additional light and sculpt a pleasing shadow on her cheek. Finally, a household fan was used to create a sense of motion.

Long Angular Faces

Angular facial features are quite common for male subjects. Accentuating your male client's angular features through lighting and, most importantly, head and body positioning will help produce a pleasing masculine portrait. Remember to pose your male clients turned toward the main light and in square and angular positions. Conversely, when photographing females with long, angular facial features, take care to maintain a soft and feminine look. Their jaw lines should not appear too masculine and angular. With careful placement

of the body and face, you can achieve a nice feminine representation of women with long angular face shapes.

Brian originally came in to the studio to create a new head shot for his acting career. Together we succeeded in creating not only an amazing head-shot, we also produced the following series of images showing how to photograph a male subject with long angular facial features. Brian is a theater professional, not a professional model. Like most clients, he had to be shown the desired pose. When this occurs, I find it easier to put the subject into the initial position myself instead of trying to explain what I want. This is one of the reasons why understanding the differences between correct masculine and feminine body positions is imperative. Notice that Brian's body is facing the main light and his shoulders and head appear square relative to the camera axis. This is a common masculine pose.

In plate 80, the main light (a Hensel Integra 500 in a medium softbox) was placed at a 45-degree angle to the subject at camera right. An incident flash meter reading was made with the dome aimed at the main light. At ISO 200, this recorded an exposure of f/13 at $\frac{1}{250}$ second.

Keeping the main light in its original position, a strip light was added at a 90-degree angle to the subject at camera left, as seen in plate 81. An amber

DIAGRAM 21—*Long angular face.*

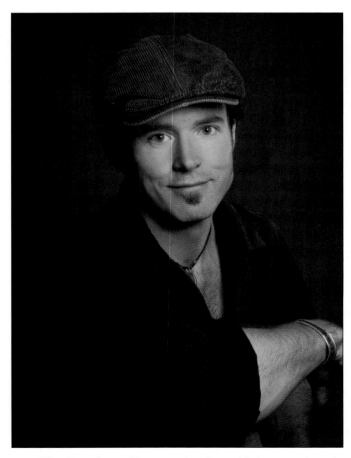

PLATE 80—*A medium softbox was placed at a 45-degree angle to the subject. (Manual mode, ISO 200, $\frac{1}{250}$ second, f/13)*

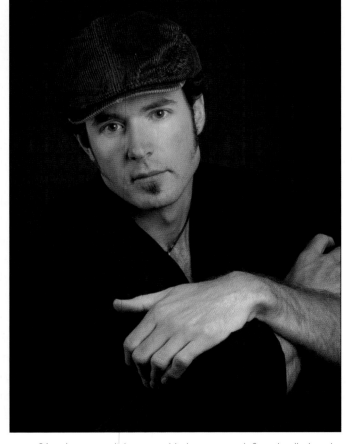

PLATE 81—*An accent light was added to camera left and gelled at the top to warm the subject's face. (Manual mode, ISO 200, $\frac{1}{200}$ second, f/13)*

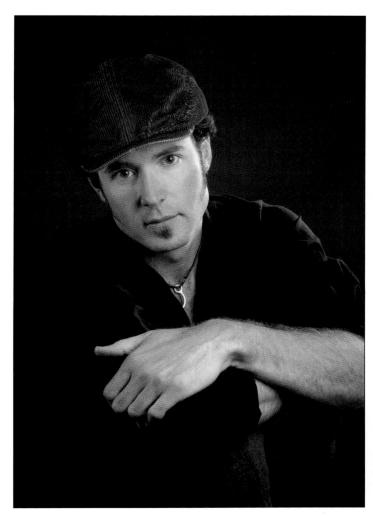

PLATE 82—*A second accent light (a 20-degree grid) was added to camera right to highlight Brian's angular jaw. (Manual mode, ISO 200, ¹/₂₀₀ second, f/13)*

PLATE 83—*Here, the second accent light was changed to a softbox for a more subtle effect. (Manual mode, ISO 200, ¹/₂₀₀ second, f/13)*

Notice how the accent light also lends a nice warm fill to the shadows.

gel was attached to the top portion of this accent light to add a slight warmth to Brian's face. Had the gel been placed over the whole face of the light, the entire right side of Brian's face would have been bathed in warmth—perhaps a little too much for my taste. The accent light was set to record an exposure value of f/16—half a stop brighter than the main light. Notice how the accent light also lends a nice warm fill to the shadows.

In plate 82, another accent light was added slightly behind the model to camera right, providing extra dimension to this portrait. This accent light was an Integra 500 monolight with a 20-degree grid that produced a hard shadow-edge transfer on the model's face. The exposure was adjusted to record an exposure value of half a stop brighter than the main light, adding a specular highlight that accented Brian's angular jaw.

To create a different feel for this final image in the series (plate 83), the 20-degree grid on the camera-right accent light was replaced with a small softbox. This produced a much softer effect. The exposures on all lights remained the same as in the previous image.

Square Faces

Similar to long angular faces, square faces can come across as masculine—in fact, most male models have square faces. When photographing females with square facial features, however, care must be taken to ensure that they do not appear too masculine.

Luciana M. Da Silva commissioned me to photograph images for her business and for a promotional card that showed her skills as a professional Brazilian belly dancer. We scheduled a session and she clearly stated that she would not pose. Instead she wanted to dance as I photographed her portrait—and that's what we did. It is important to note that honoring a client's request may be quite challenging, but it will produce images that show the client in their personal comfort zone. Most people are not used to posing for the camera, so they will be especially reliant on your professional direction and expertise in lighting when creating these images.

Luciana has amazingly beautiful features, but if she is not photographed properly (with a strong yet soft directional main light source), her square jaw can appear too angular and masculine. For the following illustrations of Luciana, Rembrandt and loop lighting patterns were chosen. These allowed a portion of her face to remain in shadow in each shot, downplaying her strong features. The main light for each shot was a Hensel Integra 500 monolight

DIAGRAM **22**—*Square face.*

PLATE **84**—*A Rembrandt lighting pattern created beautiful shadows on the model's cheekbones. (Manual mode, ISO 200, 1/250 second, f/11)*

PLATE **85**—*An accent light was added to camera right. (Manual mode, ISO 200, 1/250 second, f/11)*

PLATE **86** (LEFT)—*A backlight, fitted with an amber gel, was added to give the image a warmer feel. (Manual mode, ISO 200, ¹/₂₅₀ second, f/11)*

PLATE **87** (RIGHT)—*Finally, a fill light was added at a 75-degree angle to the subject's right side. (Manual mode, ISO 200, ¹/₂₅₀ second, f/11)*

fitted with a beauty dish. This was placed at a 45-degree angle to the dancer and aimed down onto the set. Additional lights were strategically placed and positioned to accent her beautiful jaw line and enhance her natural beauty.

As seen in plate 84, the main light was placed on full power to ensure an adequate f-stop that would allow me to use a smaller aperture (f/11) and retain my depth of field as she danced. Here, the Rembrandt lighting pattern worked well, creating a beautiful shadow on her cheekbones.

For the second image in this series (plate 85), a monolight with a 20-degree grid was placed behind and to the left of the model. This strong, directional source of illumination accented the left side of Luciana's jaw and produced a pleasing accent on her facial features. The accent light was adjusted to record at one stop brighter than the main light (or f/16). Since the model was constantly moving, setting the exposure value brighter than the main light ensured adequate exposure even if she moved farther from the light source.

Next, I added a backlight (plate 86). Because Brazil is a warm locale, I fitted this light with an amber gel to create a sense of tropical warmth. Placing a dark gel over a light source decreases your exposure; how great the decrease is depends on the density of the gel. If a gel is lighter in color, your exposure will not effectively change. You can measure the density of a gel by placing the flat disk on your meter and taking two measurements—one with the gel held

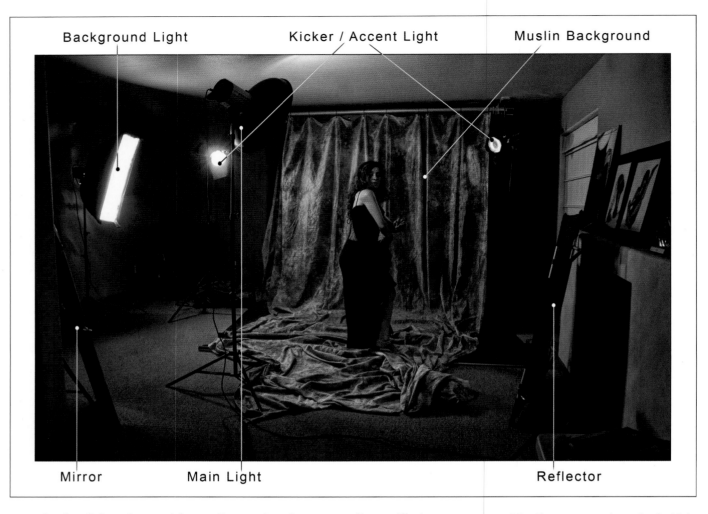

Background Light　　　Kicker / Accent Light　　　Muslin Background

Mirror　　　Main Light　　　Reflector

over the flat disk and one without. Comparing the two readings will give you an accurate exposure compensation value for the gel. *(Note:* This image was processed in Photoshop, where the background was blurred to create a shallow depth of field. This technique is ideal for separating your subject from the background.)

With the main, hair, and background lights remaining the same as in the previous image, an additional fill light was placed at approximately a 75-degree angle to the subject's right side, filling it with cooler light (plate 87; previous page). When Luciana saw the final images, she was overjoyed and told me she had never looked so good in a photograph. That's what it's all about, isn't it?

Triangular Faces

The triangular shape is extremely common and is often described as being heart-shaped. There are two possible forms: a normal triangle (with the forehead proportionally larger than the chin), or an inverted triangle (with the chin proportionally larger than the forehead). In either case, it is best to keep your subject's face in a three-quarter view to the camera if at all possible. If the subject has a wider chin, keep your camera angle high relative to your

PLATE **88**—*This set scene shows the final light placement and type of lights used to create the images of Luciana. Notice the placement of a full-length mirror at camera left. You may find it beneficial to place a mirror close by so your models can check their posing. (Manual mode, ISO 200, $1/250$ second, f/11)*

DIAGRAM 23—*Triangular face.*

subject. This will keep the forehead and chin in proportion to each other, making a more pleasant portrait. If the subject has a wider forehead, shooting at eye level with a longer lens, such as a 200mm lens, helps retain the proper perspective of the facial features.

Like oval faces, triangular faces can be successfully photographed with all light patterns and setups. If your subject has extra weight on their facial mask, however, be sure to place a portion of their face in the shadow. This will create a slimmer appearance.

Butterfly Lighting. In the following examples, we'll look at techniques for sculpting a triangular face with the butterfly lighting pattern (see page 46) and loop lighting (see page 44). Throughout the series, my main light consisted of a Hensel Integra 500 monolight with a medium softbox attached. Additional lights, reflectors, and camera angles were then incorporated to enhance the model's facial features and create a sense of depth in the final photographs.

The subject of this series of images was Irena. I originally hired Irena as my hair and makeup artist, but she turned out to be one of my favorite subjects to photograph as well. Capturing images of her is quite easy as we have built

PLATE 89—*Placing the main light, a medium softbox, three feet over the camera created a simple butterfly lighting pattern. (Manual mode, ISO 100, ¹/₂₅₀ second, f/10)*

PLATE 90—*Adding a fill light, a small softbox, to camera left added a highlight on the side of the subject's face. Having her turn her face slighting also increased the sense of depth in the image. (Manual mode, ISO 100, ¹/₂₅₀ second, f/10)*

a strong friendship. For this photograph (plate 89; previous page), my main light was placed approximately three feet above the camera to produce a simple butterfly lighting pattern. This lighting pattern works well with Irena's triangular face, because she has slight features and no additional weight on her facial mask. Subjects with extra facial weight would not be ideal candidates for the butterfly technique due to its minimal shadowing and widening of the facial mask. Using an incident flash meter, I recorded an exposure of $^1/_{250}$ second at f/10 (ISO 100).

With the main light in place, a small softbox was positioned to camera right and set to record a half stop brighter than the main light, or f/11 (plate 90; previous page). Placed farther from the subject, this added a slightly specular highlight to the side of her face. Irena was also directed to turn her face slightly away from the main light, which increased the look of depth in the portrait. (*Note:* Should you choose to incorporate a hand in your portrait, place it with care. Female subjects should retain a soft curvature to their fingers; male clients can get away with a masculine clench of the fist.)

For plate 91, Irena was directed to drop her right shoulder to add more design to the portrait. A small softbox was also added behind Irena as a hair light, creating further depth and separating her black hat from the back-

Should you choose to incorporate a hand in your portrait, place it with care.

PLATE 91—*A hair light was added for depth and separation, and the accent-light setting was increased by half a stop. Adjusting the subject's pose and the camera angle changed the lighting on the subject's face. (Manual mode, ISO 200, $^1/_{125}$ second, f/10)*

PLATE **92**—*Putting your client at ease helps to draw out their real personality. (Manual mode, ISO 200, ¹/₁₂₅ second, f/10)*

You will see your subject's confidence skyrocket, which helps immensely in the process . . .

ground. As Irena's pose was adjusted, the accent light to camera right was increased by an additional half stop, which created a beautiful specular highlight on her left cheek. Can you see how changing your subject's position and the camera angle will also change the lighting pattern on your subject's face?

Directing your clients through posing and creative lighting is important. You will find that your average client is not comfortable in front of the camera, so it is essential for you to help put them at ease and build trust with them. Asking your clients to bring their own music to play during their session is one way to put them at ease. You might also try complimenting them on one particular feature, such as their eyes or cheekbones. You will see your subject's confidence skyrocket, which helps immensely in the process of making beautiful portraits.

I find it useful to use adjectives to describe the feeling of the final portrait and the direction I want the subject to go—words like happy, sad, serious, shy, surprised, gentle smile, etc. Talking with your subjects and sincerely giving positive affirmations will make them feel comfortable and enable you to capture their personalities, as in the final image of Irena in this series (plate 92).

Loop Lighting. Now, let's look at a series of images that employ loop lighting on a subject with a triangular face. Our subject is, again, Irena (wearing an original design by Roxanne Nicoll). In this series of images, the main light (at f/8) was placed at a 45-degree angle to the subject and above her eye level. This resulted in a loop-light pattern that gave a nice shape to her triangular face. As noted, people who have this face shape tend to photograph better with a slightly higher camera angle, as was used here (plate 93).

To create plate 94, a small softbox was attached to an Integra 500 monolight and used to accent Irena's flaming red hair. The hair light was adjusted to record an exposure one stop brighter than the main light (or f/11). Desiring a more interesting angle, I stood on a chair and shot down onto the model, which created a better representation of her face. Notice how merely placing a hair light separated Irena from the background and created some additional dimension in this image.

The previous image of Irena (plate 94) is quite an acceptable portrait. However, if you wanted to create additional depth, you could add another ac-

People who have this face shape tend to photograph better with a slightly higher camera angle.

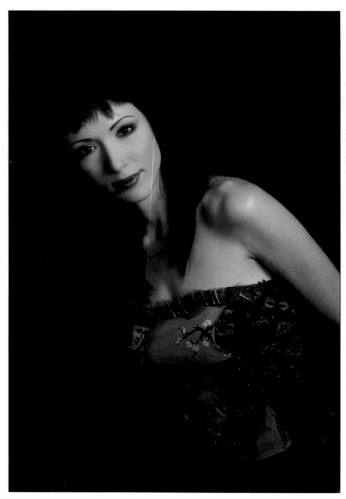

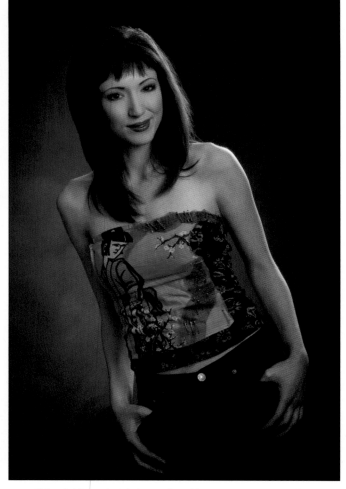

PLATE **93**—*As in the previous series of images, the main light was a medium softbox. Here, it was placed at a 45-degree angle to the camera and above the subject's eye level. (Manual mode, ISO 100, ¹/₁₀₀ second, f/8)*

PLATE **94**—*Adding a hair light produced better separation and accentuated Irena's red hair. (Manual mode, ISO 100, ¹/₁₀₀ second, f/8)*

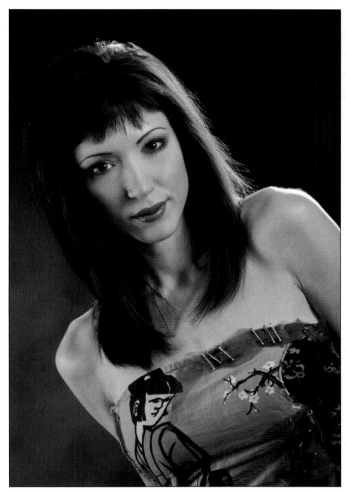

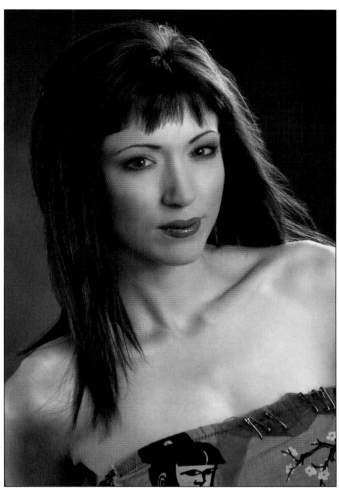

PLATE 95—*A strip light was placed to camera left to create an accent of light on Irena's shoulder. (Manual mode, ISO 100, ¹/₁₀₀ second, f/8)*

PLATE 96—*The final touch was the use of an ordinary household fan to add movement to the image. (Manual mode, ISO 100, ¹/₁₀₀ second, f/8).*

The final touch was the addition of a fan to give the image a little movement.

cent light to illuminate a particular area. In this example (plate 95), a small strip light was adjusted to record one stop brighter than the main light (or f/11) and placed to camera left to create an additional specular highlight on Irena's shoulder. The final touch, seen in plate 96, was the addition of a fan to give the image a little movement.

Be Prepared and Customize Your Lighting

Years ago, I had the opportunity to study with the "Master of Lighting," the late Dean Collins. I remember him stressing the importance of "tearing down." This refers to taking apart a lighting set after each session. This principle is essential because it forces you, as the image-maker, to look at every subject individually and to light each subject based on his or her particular facial features. It is also a good practice to meet with each subject before the day of the photo shoot to get an idea of how you will light them. That way, when the session day arrives, the optimal lighting setup can already be in place when they arrive for their session and you can concentrate on directing them to pose for the desired light patterns.

Additional Corrective Techniques

In addition to identifying the shape of your subject's face, there are a number of other strategies you can use to ensure that you produce the most flattering portrait possible. The following are some common issues and solutions for addressing them.

The following are some common issues and solutions for addressing them.

Heavy SubjectsShort lighting, Rembrandt lighting, dark clothing, higher lighting ratios (more shadows), props to conceal problem areas

Thin SubjectsBroad lighting, butterfly lighting, lighter clothing, lower lighting ratios (less shadows)

Double ChinPose subject with body leaning forward and chin stretching forward, raise main light to create shadows under the chin, use higher lighting ratios (create shadows)

Asymmetrical Features . .Three-quarter views, split-light pattern

Deep-Set/Dark Eyes . . .Lower main light, use reflectors, lower lighting ratio

Balding HairDo not use hair light

GlassesAdjust glasses down at angle to reduce reflections, remove the lens or glasses, place the main light high and watch for reflections

Large ForeheadThree-quarter view of face, raise head and lower camera angle

Crooked NoseThree-quarter view of face shooting into the top of the bend, light from the side of curve

Crossed/Lazy EyesThree-quarter view of face or profile, keep lazy eye farther from the camera

WrinklesSoft lighting, butterfly or open-loop lighting patterns, low lighting ratio

Dark SkinOverexpose one stop, light clothing, double accent/kicker lights

Light SkinDark clothing, feather the main light, higher light ratios (use shadows to shape)

MenBody facing main light, angular posing, double accent lights, straight-on pose okay, back shoulder higher than front shoulder.

WomenBody turned away from main light, tilt head to create curves in pose, front shoulder higher than back.

6. Working with Multiple Subjects

As the number of individuals increases so does the degree of difficulty. It is important that you look at each subject on an individual basis so that each subject is lit as if posing for a single portrait. Talk to your clients and educate them as to what makes a beautiful, artistic portrait. For example, let them know that their eyes and shoulders should not be on the same plane, and that you will direct an initial pose and their placement as necessary. Whatever you can do to put your clients into their comfort zone will make your job that much easier.

Whatever you can do to put your clients into their comfort zone will make your job that much easier.

The Importance of the Consultation

An initial consultation will further help you and your clients create a successful portrait. It can give you a chance to "read" the subjects' features and better determine the lighting and posing options you can use to create a flattering and successful portrait. It will also help the clients relax and reduce anxiety during the session.

Additionally, the clothing selection for the final portrait can be discussed at the pre-session consultation—and this can mean the difference between an adequate photograph and an heirloom portrait that will last for years. Keep in mind that the clothing people feel comfortable wearing everyday is not always the ideal choice for a portrait. Take a look at plate 97, a portrait of Debra and David. Debra likes to wear black and looks nice in it. In photography, however, black clothing tends to blend in with dark skin. The reverse is true for people with light skin; light colors on a light-skinned person tends to make their facial features wash out. A portrait is designed to bring attention to the subject's face, which is why clothing choice is important. In the following series of images, you'll see a better clothing choice for Debra and David.

PLATE **97**—*The clothes that we feel comfortable wearing everyday are often not the ideal choices for portrait photography. (Manual mode, ISO 100, ¹/₁₀₀ second, f/8)*

Skin-Tone Differences

The following series of photographs illustrates a particularly difficult portrait situation: photographing subjects with very different skin tones.

I met David and Debra Draughon when they commissioned me to photograph their wedding, during which we built an ongoing friendship. This image of David and Debra (plate 98) was created with a Hensel Integra 500 monolight with a beauty dish attached as the main light. This was placed three feet above the camera to produce a butterfly light pattern. Angling the main light down toward the subjects provided an equal amount of illumination on each. Though this technique is adequate for subjects with similar skin tones, it is not ideal for subjects with contrasting skin tones. To obtain the correct exposure for David, Debra's skin color was rendered darker than normal. This difference in exposure could be custom-corrected using Photoshop. However, it is best to expose the image properly from the start. (*Note:* A small strip box placed at a 65-degree angle to camera right illuminated Debra's shoulder and cheek.)

A simple technique to remember when photographing subjects with differing skin tones is feathering. This means adjusting the head of the light, not the stand, to the side so that the dimmer edge of the light (rather than the brighter core) strikes the subject. In plate 99, the main light was feathered away from David and toward Debra. This meant more light fell on her skin

PLATE **98** (LEFT)—*The main light strikes both of the subjects evenly from the front, creating a portrait with little facial modeling and a less-than-ideal representation of their skin tones. (Manual mode, ISO 100, ¹/₁₀₀ second, f/8)*

PLATE **99** (RIGHT)—*Feathering the main light away from David and toward Debra created a more pleasant representation and better shadowing on the right sides of their facial masks. (Manual mode, ISO 100, ¹/₁₀₀ second, f/8)*

In this image, the main light was feathered away from David and toward Debra.

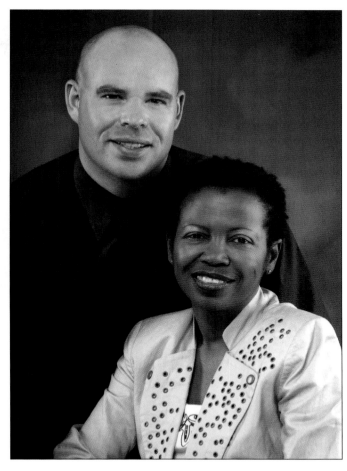

PLATE 100 (LEFT)—*Placing an accent light to camera right added depth in the image. Placing the subject with the darker complexion closer to the camera produces a perfect exposure on both subjects. (Manual mode, ISO 100, $^1/_{100}$ second, f/8)*

PLATE 101 (RIGHT)—*Finally, a medium softbox was positioned slightly behind the subjects to camera right and feathered in to add light to the background. (Manual mode, ISO 100, $^1/_{100}$ second, f/8)*

Finally, a medium softbox was positioned slightly behind the subjects to camera right . . .

and less direct light illuminated David. The result is a more pleasant rendition of the couple. A bonus was the added shadowing this produced on the right sides of their facial masks. Note, too, that the small strip light softbox (used as an accent light) placed to the subjects' left was moved to a 90-degree angle. Repositioning this accent light reduced the intensity of the light on Debra's left cheek and illuminated the background slightly.

Plate 100 illustrates another effective technique for photographing a combination of diverse skin tones, placing the lighter-skinned subject farther from the light source. In this case, David was posed behind his bride, and Debra was moved slightly closer to the feathered main light, giving additional exposure to her darker skin. In this image, further separation was created by increasing the intensity of the accent light by approximately half a stop. Additionally, a small softbox was placed slightly behind the subjects' left, which produced a pleasant highlight on David's left cheek, adding depth and shadowing to his features. Using a strip light helped keep this illumination within a concentrated area, adding a beautiful highlight on Debra's cheek.

To create the final portrait (plate 101), a medium softbox was placed to the right of the subjects to slightly fill the shadows. The light was feathered slightly toward the background, creating additional illumination and enhancing the sense of dimension in the image. Lastly, a zebra Sunbounce reflector was placed under the faces to add sparkle and fill on the eyes.

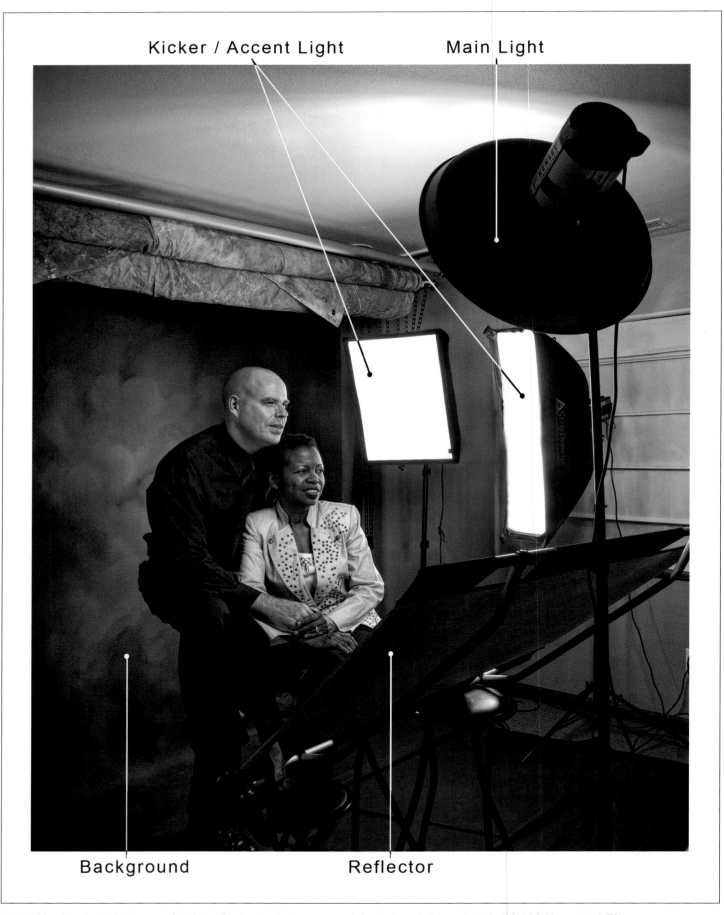

Kicker / Accent Light Main Light

Background Reflector

PLATE 102—*The final lighting setup for plate 101. (Accent light to camera left not shown.) (Manual mode, ISO 100, $^1/_{100}$ second, f/8)*

Face-Shape Differences

The photograph is an adequate representation of the couple, but it could be much better.

This series of images of Jason and Kendra Lippert illustrates the use of sculpting techniques for multiple subjects. Kendra and Jason represent the average couple you will encounter during a portrait session. Looking at each subject as if you were planning to photograph them individually will help to create a beautiful portrait that accents the differences of each face. In this case, Jason has a rectangular face and Kendra has square facial features.

The first image (plate 103) was created for the couple on the eve of their engagement. A single main light was used—a Hensel Integra 500 with a beauty dish attached. This was placed about four feet from the subjects at a 45-degree angle. The photograph is an adequate representation of the couple, but it could be much better.

Keeping the main light in its original position, I added a small softbox attached to a Hensel Integra 500. This was feathered toward the rear to illuminate the canvas background and metered approximately one stop brighter than the main light, producing the necessary separation for Kendra's hair (plate 104).

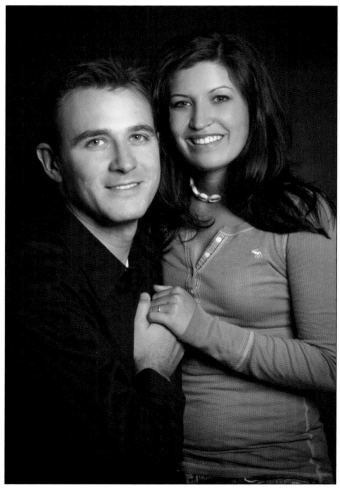

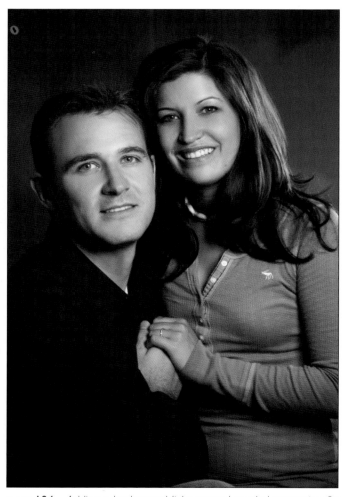

PLATE 103—*The couple was photographed with the main light, a beauty dish, placed four feet from them at a 45-degree angle. (Manual mode, ISO 200, $^1/_{125}$ second, f/8)*

PLATE 104—*Adding a background light created needed separation for Kendra's dark hair. (Manual mode, ISO 200, $^1/_{125}$ second, f/8)*

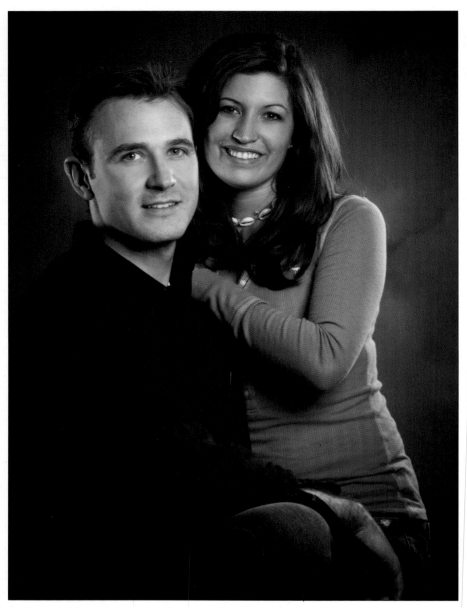

PLATE 105 (LEFT)—*An accent light was added to camera left to sculpt Jason's cheekbones. (Manual mode, ISO 200, $^1/_{125}$ second, f/8)*

PLATE 106 (FACING PAGE)—*The final portrait flatters the face shapes of both subjects. (Manual mode, ISO 200, $^1/_{125}$ second, f/8)*

Next, a strip light was adjusted to record half a stop brighter than the main light and placed to camera left (plate 105). This accent light provided a pleasant specular highlight on Jason's chiseled cheekbones.

The final image of Jason and Kendra (plate 106) took into consideration their individual facial structures. Wanting to add a sense of dramatic depth to Kendra's beautiful square features, I used a subtractive-lighting technique. After adjusting the pose of the couple, I placed a gobo to the left of Kendra's face, producing a nice shadow on her jaw. Incidentally, adjusting the couple's pose created a beautiful specular highlight on Jason's left temple for added depth. Take a look at plate 103 and compare it with this final image. You will see how a little thought in lighting can turn an ordinary portrait into an extraordinary portrait.

I placed a gobo to the left of Kendra's face, producing a nice shadow on her jaw

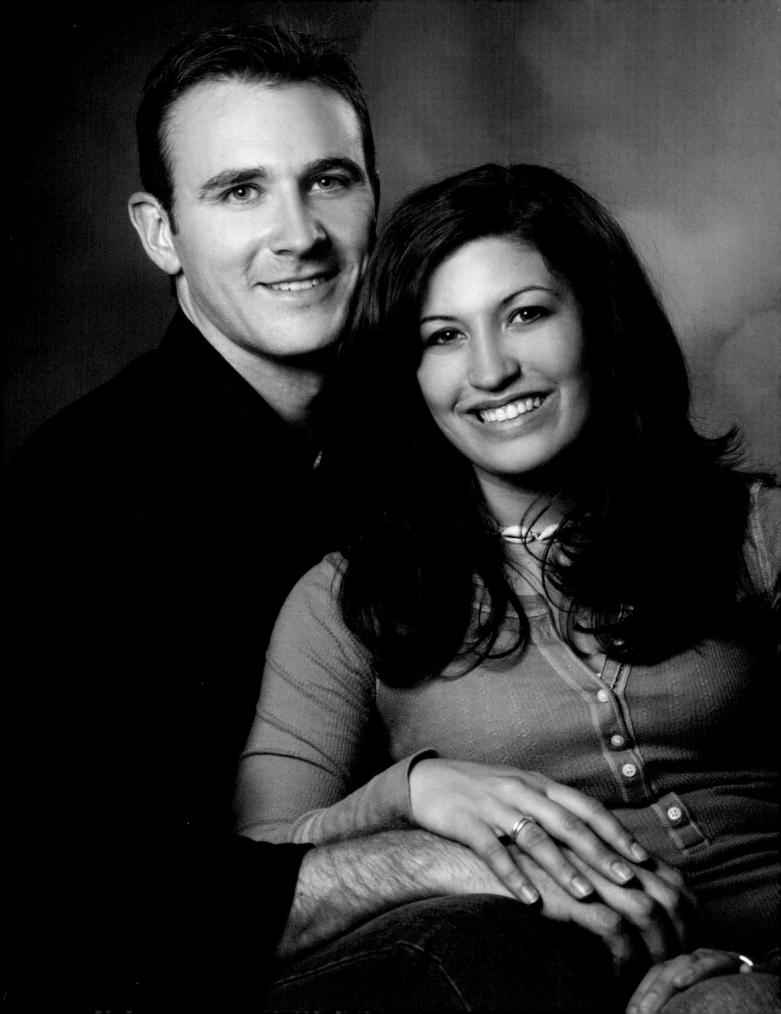

7. Sculpting with Ambient Light

When talking about ambient light, we are referring to light (of all types) that is present in and around the area where we are photographing—light that we do not add to the scene or subject(s). Ambient light (also called available light) can come from the sun, the lamps or overhead lights inside a chapel or other room, or a variety of other sources. Ambient light can be measured using an incident light meter and controlled using a combination of shutter speed and aperture. Additionally, ambient light can be redirected using reflectors, diffused with scrims (also called silks or panels), and/or blocked with gobos (such as flags and black cards).

I feel that the sun should be used and controlled just as you would in a studio environment.

Sunlit Portraits

The Challenges of Sunlight. When you photograph using the sun as your only source of illumination, it is important that you learn to "see" the light and its effect on your subject. Sunlight is, of course, a notoriously challenging source of lighting for portraiture. In fact, a student once informed me that her previous photo instructor had told her to avoid the sun like the plague—and to always keep the sun behind the subject and flash them with straight flash. I strongly disagree.

Instead, I feel that the sun should be used and controlled just as you would control the lights in a studio environment. As in the studio, the position of the sun (the main light) will determine the lighting pattern on your subject's face. The only difference is that you can't move the sun when you want to change the lighting. As we've seen in previous studio examples, however, you can accomplish the same effect by moving your subject instead.

DIAGRAM **24**—*The position of the subject's face in relation to the sun dictates the lighting pattern that will be created.*

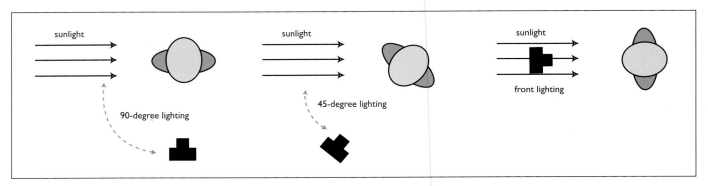

PLATE 107—*The image of Alena was created with the sun as the only source of illumination. The sun was at high noon and created unpleasant shadows under her eyes. This is not the ideal time of day to photograph portraits. (Program mode, ISO 100, ¹/₂₅₀ second, f/5.6)*

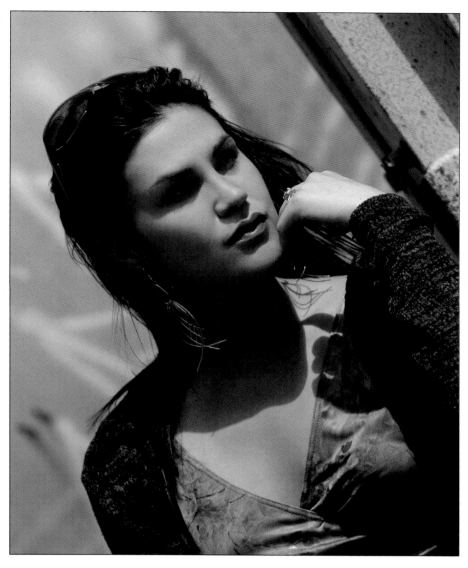

An important factor in using sunlight is predetermining the best time of day to photograph your subjects.

An important factor in using sunlight is predetermining the best time of day to photograph your subjects. This will greatly enhance your ability to produce pleasing portraits. It is not ideal to photograph portraits between the hours of 11:00AM and 1:00PM because the sun is directly overhead and will create unpleasant shadows under the eye area and facial mask, as seen in plate 107. The light's color temperature is also not ideal at this time of day.

A better time of day for portrait photography is early in the morning or later in the evening. At these times of day, the sun is lower in the sky. This lower angle is more similar to the angles at which you would place your main light in the studio and results in the same flattering lighting patterns on the face. The light at these times of day also tends to be more golden, creating more appealing skin tones.

Using the Sun Alone. The following photographs illustrate how using the sun to your advantage can create pleasing images with essentially the same lighting patterns as you would see in images made in the studio. For example, plate 108 (next page) is an image of Michael Johnson that was created for

PLATE 108 (FACING PAGE)—*Careful subject positioning was used to create a loop-lighting pattern in this ambient-light portrait. (Shutter priority mode, ISO 200, ¹/₂₅₀ second, f/10)*

PLATE 109 (ABOVE)—*Late-day sun helped created warmth in this portrait, shot with a Rembrandt lighting pattern. (Shutter priority mode, ISO 200, 1/250 second, f/11)*

his portfolio. We have become great friends and always come up with different themes for his portfolio shots. This day proved to be no different. Michael, a photographer himself, scouted the location and time of day to ensure dramatic light. An incident ambient exposure reading was recorded and the camera set accordingly. By adjusting Michael's head placement, I produced a portrait with dramatic loop lighting on his face.

On a beautiful sunny day, David Thompson and I drove his motorcycle through the yellow aspen groves of Colorado and came across the abandoned train car seen in plate 109. Fortunately, I had my camera and created this image as an illustration of the sun producing a beautiful dramatic Rembrandt lighting pattern. The portrait was created around sunset, when the sun is lower on the horizon and produces a natural warm light.

My dear friend Bob Ray, of California, created a beautiful portrait of Severine Tasset while in Italy (plate 110; next page). Severine was posed lying on her side in a living room, in front of a green couch. A black leather jacket was draped behind her to create a low-key background. She was lit only by win-

Learning to recognize the natural reflectors that exist all around us can add a nice look to your outdoor photographs.

dow light, which streamed through a sliding glass door to camera right. The curtains on this window were drawn but parted slightly, creating a natural strip light.

Photographer Taralyn Turner Quigley created this beautiful bridal portrait of Rebecca Bruns (plate 111) using only sunlight. Taralyn arrived at the chapel early to scout out possible locations to create a soft formal portrait of her bride. Selecting the location, she positioned Rebecca close to a sunlit arched window that acted as a natural diffuser. Taking extra time to familiarize yourself with your shooting situations will greatly enhance your ability to create beautiful images.

PLATE 110 (FACING PAGE)—*Partially drawn curtains created a natural strip light that illuminated this portrait by Bob Ray. (Aperture priority mode, ISO 640, ¹/₆₀ second, f/11)*

PLATE 111 (RIGHT)—*Window light often provides a naturally soft source of lighting, as seen in this bridal portrait by Taralyn Turner Quigley. (Manual mode, ISO 250, ¹/₁₀₀ second, f/2.8)*

PLATE 112 (FACING PAGE)—*Jon Asp created this portrait of the groom using reflected light. (Aperture priority mode, ISO 125, 1/200 second, f/4.5)*

PLATE 113 (ABOVE)—*This portrait, photographed in Weston, MO, was created by posing the subjects between two old buildings, which served as natural reflectors. Meryl was wearing white pants, but I came prepared with a blanket for them to sit on—a good practice for all your location shoots. (Manual mode, ISO 1600, 1/400 second, f/8)*

Using the Sun with Natural Reflectors. Learning to recognize the natural reflectors that exist all around us can add a nice look to your outdoor photographs. For example, try positioning your subject under a white porch where sunlight is able to bounce onto him or her, allowing the shadows to be filled with natural light. Alternately, look for reflective surfaces, such as a nearby white wall or other highly reflective material, and find ways to incorporate this light into a beautiful portrait.

Jon Asp of Colorado photographed plate 112, a wedding-day image of groom John Teten. Jon recognized the harsh Colorado sun and positioned his subject in a stairwell that had a naturally reflective surface. An incident meter reading was made and the camera set accordingly. With the sunlight behind the subject, light reflected off the granite to camera left produced a pleasant image that clearly sculpted the groom's face.

Scouting locations to photograph Meryl Vedros and Daniel Davis was a bit challenging as we were shooting on a bright, sunny day (plate 113). I finally found the perfect spot between two old buildings. The location was very narrow and the models were agreeable to sit in the garden next to an antique

birdbath. An incident meter reading was made with the meter pointing toward the light that was shining in between the buildings. The recorded exposure was f/8, and a higher ISO setting was chosen to create a little more grain, which worked well for this particular portrait.

This beautiful image of Meryl Vedros (plate 114) was created with the sun behind the model, resulting in the beautiful accent light on her left cheek. The main source of illumination came from the sun bouncing off the white building directly in front of the model, which produced a gentle lighting quality that was perfectly suited to her soft features. To determine the correct exposure, an incident-light reading was made with the dome of the meter at the subject position and facing the camera.

In plate 115, Misty Nink was photographed with the intense Arizona sun bouncing natural light in under the covered courtyard of the reception area. Misty's groom, Ryan, was asked to stand to camera right so that his black

The main source of illumination came from the sun bouncing off the white building . . .

PLATE 114—*With the sun behind the subject, reflected light from a white building served as the main light. (ISO 200, $^1/_{60}$ second, f/5)*

PLATE 115—*For this reflected light portrait, the groom was actually used as a gobo! (Manual mode, ISO 400, ¹/₃₀ second, f/8)*

The trick is to really see the lighting effects produced on the facial mask.

tuxedo would act as a gobo, blocking additional light from bouncing onto the left side of the bride's face. Being able to improvise in fast-paced situations is helpful in creating images with depth and dimension.

Adding a Reflector. Once you are familiar with the principles of light and its effects on your subjects, using the sun to your advantage becomes second nature. The trick is to really *see* the lighting effects produced on the facial mask. Then, you can use reflectors or scrims to redirect the light in any way that helps give shape to your subjects.

When using a reflector, I have found it works best to move the reflector back and forth (left to right) a bit so that you can see the actual light it is kicking back onto your subject. The object is to add a slight fill that looks natural; overlighting your subject is just as detrimental as using flat lighting. The following series of photographs illustrates the effects of using reflectors

to help redirect the ambient light. In most cases it is not necessary to re-meter the light being reflected or diffused, though an initial incident measurement is essential.

Plate 116 was made entirely with mid-morning available light. Alena was posed so that the sun illuminated her facial mask and created a natural loop-lighting pattern. An incident meter reading measured an exposure of f/11 and my camera was set accordingly. Notice how the light produced a lighting ratio that is higher than is normally desirable.

To reduce the lighting ratio, the model was kept in the same position but a micro-mini silver Sunbounce reflector was placed slightly behind her to camera left (plate 117). This bounced sunlight back onto the model, opening up the shadows and producing accents (and separation) on her hair and right cheek.

Care must be taken when bouncing the light. In plate 118, the reflected light is actually too strong on Alena's right cheek. As a result, the overall lighting is flat and not as attractive as it could be.

The final image of Alena (plate 119) illustrates the benefits of moving the reflector and observing where the light is falling relative to the shadows. In this case, the reflector was placed at approximately a 90-degree angle to Alena's right (as seen in plate 120).

Diffusing the Light. In portrait photography, you are dealing with real-life situations—which are not always ideal shooting situations. For this reason, being able to improvise and control your light, regardless of

PLATE 116 (TOP)—*Mid-morning available light produced a lighting ratio that was too high for a flattering portrait. (Manual mode, ISO 200, $^1/_{125}$ second, f/11)*

PLATE 117 (CENTER)—*Adding a reflector to camera left opened up the shadows and improved separation. (Manual mode, ISO 200, $^1/_{125}$ second, f/11)*

PLATE 118 (BOTTOM)—*Too much reflected light results in a flat look. (Manual mode, ISO 200, $^1/_{250}$ second, f/11)*

\PLATE 119 (ABOVE)—The reflector was placed at about a 90-degree angle to Alena's right to create this final portrait. (Manual mode, ISO 200, $^1/_{250}$ second, f/11)

PLATE 120 (RIGHT)—The set scene of the final image of Alena illustrates the placement of the micro-mini silver Sunbounce relative to the subject. (My dear friend and photo student Heather ter Steege kindly assisted by holding the reflector for this session.)

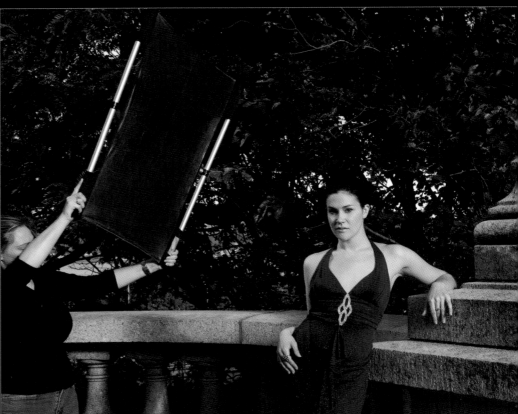

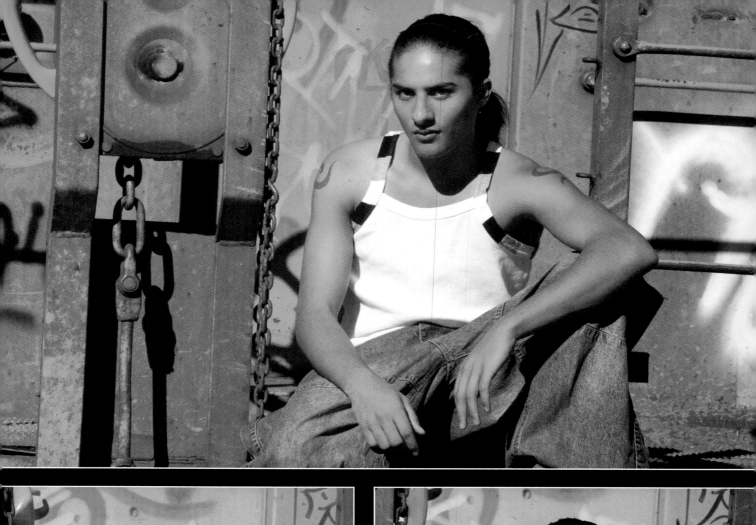

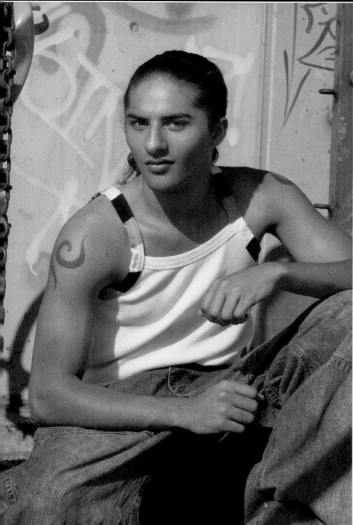

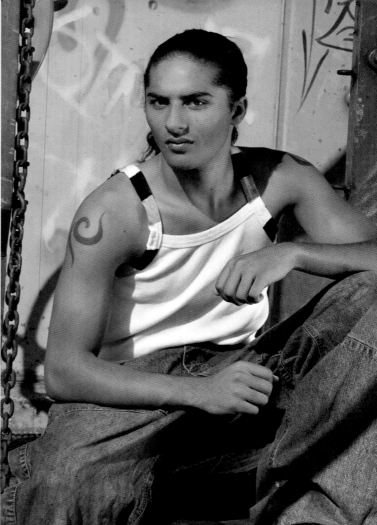

the time of day, will be a benefit. The next series of images of Trae Phillips was made for the young man's modeling portfolio. We were scheduled to shoot earlier in the day, but an emergency came up and we were forced to postpone the shoot to a later hour. I had just been introduced to the California Sunbounce Sun Swatter light diffuser, so I was confident the images for Trae would be beautiful.

The concept for Trae's portfolio was an urban feel. The location and wardrobe were selected in a consultation before the session. Using the sun as the main source of illumination for plate 121, the incident-light reading was $\frac{1}{320}$ second at f/11 (ISO 200). Notice, however, how hard the light was on Trae's face. To diffuse the light (plate 122), a Sunbounce Sun Swatter was placed between the sun and the subject. Notice how this diffused the harsh sun and created a softer quality of light for the portrait. Without changing the set, a Sunbounce zebra reflector was then added to camera right to open up the shadow on Trae's cheek (plate 123). If you study the progression of images in this series, the differences in their depth and dimension are quite noticeable.

More often than not, Mother Nature does not cooperate with our time schedule when photographing portraits. People are busy and scheduling sessions can prove to be challenging. Therefore, you must work at whatever time of day works best for your clients. Knowing how to control the light at any particular time of day or in any given sun conditions is essential to accommodating clients and producing world-class images.

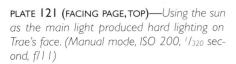

More often than not, Mother Nature does not cooperate with our time schedule.

PLATE 121 (FACING PAGE, TOP)—*Using the sun as the main light produced hard lighting on Trae's face. (Manual mode, ISO 200, $\frac{1}{320}$ second, f/11)*

PLATE 122 (FACING PAGE, BOTTOM LEFT)—*Diffusing the sunlight gave it a softer quality. (Manual mode, ISO 200, $\frac{1}{320}$ second, f/11)*

PLATE 123 (FACING PAGE, BOTTOM RIGHT)—*A reflector to camera right added fill on Trae's cheek. (Manual mode, ISO 200, $\frac{1}{320}$ second, f/11)*

PLATE 124 (RIGHT)—*Here you can see the unique design of the Sunbounce Sun Swatter. The lightweight translucent material acts as a large softbox placed between the sun and the subject. (Friends and photo students Roseburrow and Kathy assisted.)*

Adding Flash

Sunlight and Fill Flash. In some cases, using reflected light for fill is impossible or impractical. In those cases, you may wish to use fill flash instead. When combining ambient light and fill flash, it is important to understand that the ambient light exposure is controlled by the shutter speed, while the flash exposure is controlled by the aperture (and the power setting on the flash). This means that setting your camera to the shutter priority mode will allow you optimum control over the exposure and feel of the image. In the shutter priority mode, you choose the shutter speed needed to properly expose the ambient light in your image; the camera selects the best aperture. Your flash exposure and intensity can then be adjusted via the power controls on the flash unit(s). Indoors or outdoors, shutter priority works to the photographer's advantage; more control equals more pleasing photographs.

Indoors or outdoors, shutter priority works to the photographer's advantage . . .

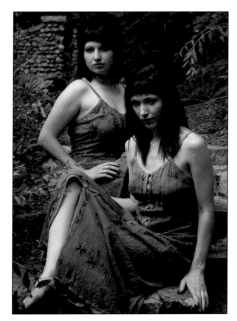

PLATE 126—*A diffuser placed between the sun and the subjects softened the harsh lighting. (Program mode, ISO 100, $\frac{1}{60}$ second, f/4.5)*

Let's go back to the set of images used at the beginning of the book. The following series of Irena and Rita clearly illustrates a complete photographic sculpting series utilizing ambient light mixed with artificial strobes.

When I shot plate 126, the sun was going in and out of a cloud bank. Therefore, a 4x6-foot Sunbounce white translucent silk scrim was placed in the trees to camera left to diffuse the harsh shadows from the sun. The camera was set to the program mode and the exposure was made at $\frac{1}{60}$ second at f/4.5 (ISO 100).

Plate 127 shows the ill effects of setting your camera on the program mode and allowing the camera's internal metering to create a flash image. Though the flash was taken off the camera and handheld at a 45-degree angle, the overall photograph still looks like a snapshot. The flash looks too harsh (notice the shadow behind the models) and the background appears to be underexposed.

The final image (plate 128) was created by bouncing a Nikon Speedlight flash into a mini Sunbounce zebra reflector placed at camera left. This slightly filled the shadow side of the models. The ambient exposure was recorded and the camera was set to $\frac{1}{60}$ second at f/4.5. The flash power was reduced to half power to create this beautifully lit portrait.

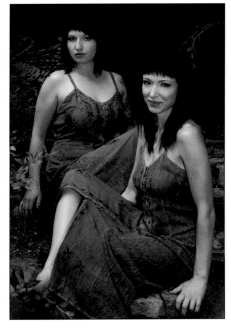

PLATE 127—*Off-camera flash was added—but shooting in the program mode created too harsh an effect. (Program mode, ISO 100, $\frac{1}{60}$ second, f/4.5)*

PLATE 128 (RIGHT)—*The power of the off-camera flash was reduced, and a second flash was bounced into a reflector at camera right for fill. Selecting a longer shutter speed allowed more ambient light to record, giving a better look on the background. (Shutter priority mode, ISO 100, $\frac{1}{60}$ second, f/4.5)*

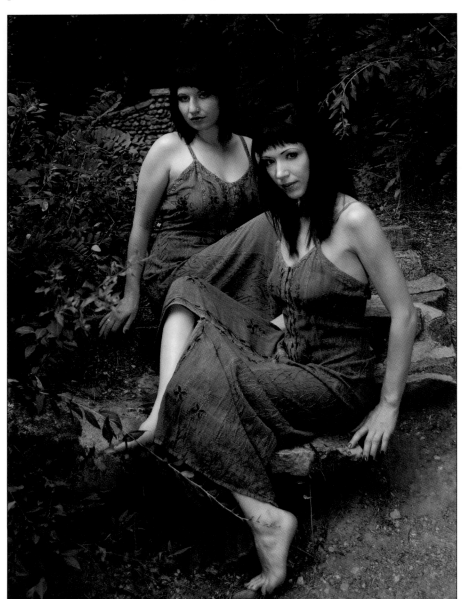

The following images of Michael Johnson and Miranda Hatfield illustrate a similar technique of combining flash and ambient light using the camera's shutter priority mode and incorporating a reflector. Which of these images would you like to show the client?

Michael and Miranda enjoy the outdoors and commissioned me to create a portrait that depicted their new love for each other. We hiked up a glacier in Colorado to create this beautiful portrait (plate 129). An incident meter reading was recorded by placing the light meter at the subjects' position with the dome facing the camera. The recorded exposure of the light falling on the subjects was ¹⁄₄₀₀ second at f/2.8 (ISO 200). The camera was set to shutter priority, as I wanted the highest possible shutter speed to ensure that my 70–200mm lens would not record camera movement. The straight image produced beautiful highlights on their hair, but the couple's face is a bit too shadowed. I could go into Photoshop to lighten the faces and spend a lot of time "fixing" the lighting, but our objective is to create a beautiful portrait from the start.

Keeping the same setting on the camera, a flash was attached and an image made (plate 130). As you can see, the flash is too strong and does not create dimensional depth or sculpting on the facial features of this beautiful couple.

PLATE 129—*The straight image has nice highlights, but the light on the subjects' faces needs some work. (Shutter priority mode, ISO 200, ¹⁄₄₀₀ second, f/2.8)*

PLATE 130—*Adding a flash to the setup resulted in a flat image. (Shutter priority mode, ISO 200, ¹⁄₄₀₀ second, f/2.8, on-camera flash)*

Using the same camera settings as recorded with a light meter, I set my flash to half power and bounced it into a mini Sunbounce zebra reflector. The reflector and flash were positioned 45 degrees to camera left, adding beautiful shadows to both faces (plate 131). A big improvement!

Shooting with Flash at Dusk. Just because the sun goes down doesn't mean your camera should be put away—in fact, late-day light is often referred

PLATE 131 (FACING PAGE)—*The power of the flash was reduced and the flash was bounced into a reflector to camera left. The result is much better sculpting on the couple's faces. (Shutter priority mode, ISO 200, ¹⁄₄₀₀ second, f/2.8)*

to as "sweet light" because of the beautiful look it can give your images. To obtain a proper exposure it is ideal to place your camera on a tripod and work about thirty minutes after the sun drops below the horizon. As this example shows, flash can also be successfully added to these late-day shots.

Ted Mehl created this beautiful image of a bride and groom on the grounds of the Broadmoor Hotel and Resort in Colorado Springs, CO (plate 132). This image pleases me tremendously, because I have personally watched Ted grow from a novice to a spectacular photographer. Ted waited until approximately twenty minutes after sunset to capture this image—and he was sure to secure his camera to a tripod as his ambient exposures measured a second or more at ISO 500.

To illuminate the bride and groom in the scene, Ted used a monolight with a softbox attached. Desiring a soft quality of light and not wanting to "blast" his subjects, Ted set his camera's aperture at f/4, which slightly underexposed the flash intensity on the beautiful couple (plate 133).

Ted waited until approximately twenty minutes after sunset to capture this image . . .

PLATE **132** (LEFT)—*Ted Mehl captured this dusk image using available light only. (Manual mode, ISO 500, 1.6 seconds, f/4)*

PLATE **133** (FACING PAGE)—*Ted Mehl added a softbox to light the couple, but set his camera aperture to slightly underexpose the flash for a more subtle effect. (Manual mode, ISO 500, 1 second, f/4)*

Flash and Available Light Indoors. Perhaps the most misunderstood technique in photography is mixing flash with ambient light indoors. The tendency of most photographers is to set the flash power too high and shoot in aperture priority or program mode so that the flash is the dominant source of illumination.

A better technique is to use less flash power and drag the shutter. This means picking a shutter speed that is longer than your camera's sync speed and allowing ambient light to continue to register in the exposure after the burst of the flash. When doing this, the same rule applies as when shooting outdoors: the ambient light exposure is controlled by your shutter speed, and the flash exposure is controlled by your aperture. The longer the shutter speed, the more ambient light will be recorded. (Although some photographers shoot in aperture-priority mode and get beautiful results, my preference is the shutter-priority mode.)

As you study the following images and how they were made, you will see that great location photographs can be made with little equipment—if you know how to make the most of the ambient light.

Plate 134 is a portrait of chef Zach Churchill. This was an impromptu portrait created at a hotel in Kansas City, MO. Wanting to show my gratitude for Zach's deliciously prepared food, I asked if I could create an image of him holding one of his creations. The hotel lobby was the perfect setting for this

A better technique is to use less flash power and drag the shutter.

PLATE **134**—*This portrait was created in a hotel lobby and combines bounce flash with plenty of ambient light. (Shutter priority mode, ISO 1250, $^1/_{200}$ second, f/1.8)*

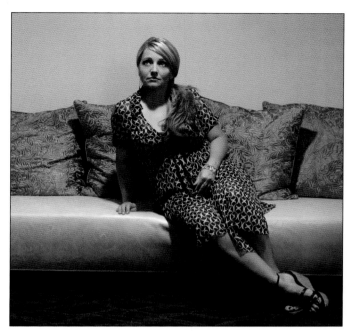

PLATE 135—Leslie was placed under an overhead light with her face positioned to produce a Paramount lighting pattern. (Aperture priority mode, ISO 2000, $^1/_{125}$ second, f/5.6)

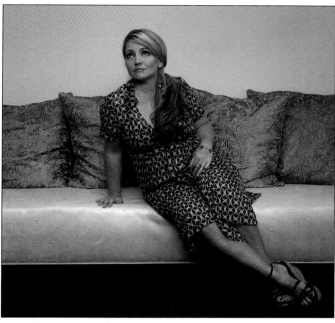

PLATE 136—A napkin was taped over the light, acting as a makeshift diffuser. (Shutter priority mode, ISO 3200, $^1/_{200}$ second, f/4)

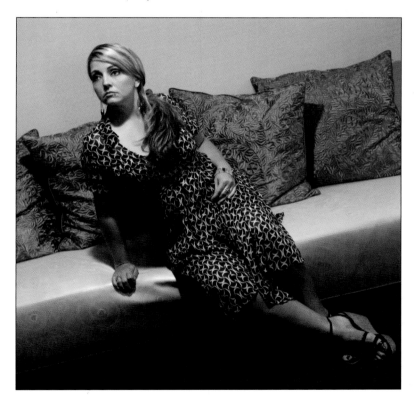

PLATE 137—A low-powered flash added fill to complete the portrait. (Aperture priority mode, ISO 2000, $^1/_{30}$ second, f/5.6)

portrait. To create it, I began by taking an incident exposure reading of the available light that would illuminate my background. Next, I took a reading of the light directly above my subject. I didn't have a tripod, so I set my camera at ISO 1250 to ensure I could use a fast enough shutter speed to confidently hand-hold the camera. (*Note:* I was using a Canon EOS 1D Mark III, which produces amazing low-noise images at high ISO settings.) The final exposure was made at $^1/_{200}$ second at f/1.8 with a Canon 580 EX flash bounced off a nearby wall.

My dear friend Leslie and I were in Kansas City attending a weekend photo workshop when I created this image in the lobby of our hotel (plate 135). An incident exposure was made at Leslie's position to record the available light. Using a Canon EOS 1D Mark III, my ISO was set to 2000, allowing me to hand-hold this available light image at $^1/_{125}$ second at f/5.6. I intentionally placed Leslie under the overhead light to create a 1940s feel to match the retro décor. Can you see how the overhead light and the placement of Leslie's head created a Paramount lighting pattern?

Looking back at the previous image, you will notice the overhead light produced a quality of light that was harder than is desirable in most portraits.

To improvise, I taped a napkin over the overhead light, which acted as the perfect light diffuser (plate 136; previous page). Can you see how the hard light source became softer? (Of course, it is a good idea to ask permission from management before trying something like this!)

To create the final beautiful location portrait (plate 137; previous page), a Canon 580 EX flash was set at one-quarter power and bounced off the wall to Leslie's right to add a slight fill.

Let's look at another series of images combining flash with indoor ambient light. Ted Mehl of Colorado created the bridal portrait seen in plate 138 using available light only. The bride posed in a doorway and reflected light bounced from the cement in front of the model. Notice the "black hole" effect behind the model. It creates a flat and non-dimensional portrait.

To improve the lighting, a studio strobe was placed inside the resort and set to record an exposure of f/11. This properly illuminated the background. In plate 139, you can see the placement of the strobe behind the bride to camera left. In the final image (plate 140), you can clearly see the control Ted

To improve the lighting, a studio strobe was placed inside the resort . . .

PLATE **138** (**LEFT**)—*Working with available light only resulted in a black-hole effect behind the model. Photograph by Ted Mehl. (Manual mode, ISO 200, $^1/_{125}$ second, f/9)*

PLATE **139** (**ABOVE**)—*A strobe, placed behind the bride to camera left, was placed to properly illuminate the background. Photograph by Ted Mehl.*

PLATE **140** (**FACING PAGE**)—*The final image is an excellent example of how flash and ambient light can be balanced. Photograph by Ted Mehl. (ISO 200, $^1/_{125}$ second, f/9)*

exercised when combining ambient light with flash.

Our next two portraits are from Kevin Kubota of Bend, OR. Plate 141 is a portrait of bride Heidi Parr that was taken during her wedding. Weddings are typically fast-paced and require the photographer to think and act quickly—there is usually only one chance to capture each event and emotion of the wedding day. This photograph shows the ill effect of relying on your camera's internal meter to control the exposure—an underexposed portrait.

The second image in this series, plate 142, reveals a much better result created using a simple but effective lighting technique that Kevin relies on quite often when shooting on location. In this setup, the lighting was created by balancing the existing light and with light from a 42-inch pop-up translucent diffuser from Photoflex. Kevin positioned the diffuser about two to three feet from Heidi, high and to camera left (at a 45-degree angle to the subject). He set his wireless TTL flash unit (Nikon SB-800) to normal exposure. Kevin used another SB-800 unit on his camera to trigger the main off-camera light, but the on-camera light was set to deliver no noticeable light itself. Setting his Nikon D1X camera to aperture priority, he used –²/₃ stop exposure compensation to lower the ambient light levels. The result is a beautifully balanced bridal portrait.

PLATE 141 (LEFT)—*Relying on your camera's internal meter can yield poor results. Photograph by Kevin Kubota.*

PLATE 142 (FACING PAGE)—*Adding diffused off-camera flash produced spectacular results that balance flawlessly with the ambient lighting. Photograph by Kevin Kubota. (Aperture priority mode, ISO 200, ¹/₃₀ second, f/2.8)*

8. Post-Production Enhancements

Now you're filled with a lot of technical information on how to shoot your clients in their best light. But what happens next? How do you differentiate yourself from the studio down the street? Personally, I use Kubota Imaging Tools to create my final masterpieces. I had the pleasure of attending a week-long workshop with Kevin Kubota where I was introduced to his imaging tools and pre-recorded actions, which are completely customizable to suit your personal vision. Below are several images that show the effect of Kevin's remarkable tools.

Plate 143 shows Savannah Baker, a high-school senior who came to my studio for a unique portrait for the yearbook. This is the beautifully lit portrait that was made. Within minutes, I created plate 144 using a combination

PLATE 143 (LEFT)—*The original image. (Manual mode, ISO 200, 1/200 second, f/22)*

PLATE 144 (RIGHT)—*Image retouched using Kubota Imaging Tools.*

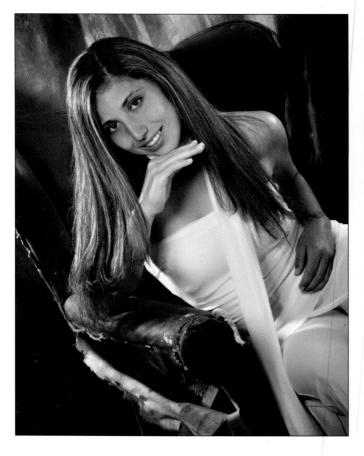

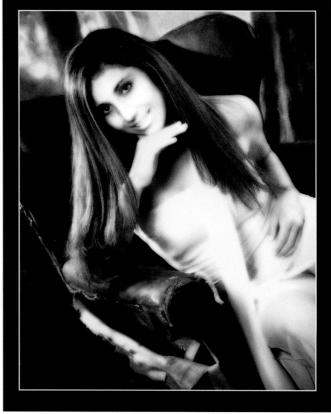

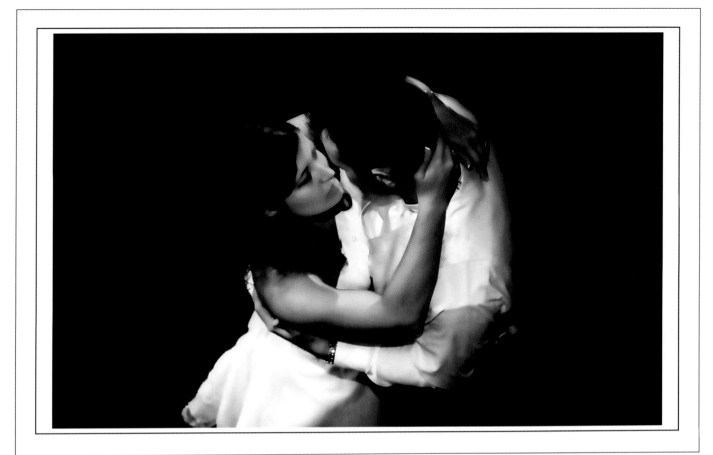

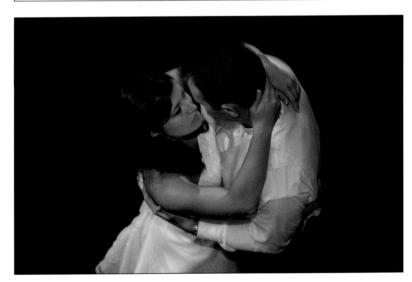

PLATE 145 (LEFT)—*The original image. (Shutter priority mode, ISO 100, ¹/₁₀ second, f/4.8)*

PLATE 146 (ABOVE)—*Image retouched using Kubota Imaging Tools.*

of Kubota Imaging tools. From Artistic Actions Vol. II v. 2.3, I selected Angel Glow and Mocha B&W, then added fill flash and the border/keyline. (Remember, all of these actions were modified to suit my personal taste.)

Plate 145 shows a very tender and loving moment I captured during Kendra and Jason's wedding. They had no idea I shot this image and it is one of their favorite images from the entire wedding day. Shooting from a balcony during their first dance as husband and wife, I set my camera to my desired shutter speed and bounced a flash, set at half power, off a white wall at camera left. When it came to completing the image in postproduction, I envisioned it as soft, innocent, loving, and intimate candid portrait. To accomplish this vision, I used the Animee Soft action from Kubota Artistic Tools Vol. III (modified to my taste) and added a black border and keyline. The result is shown in plate 146.

Linda Larkin and I met when I was commissioned to photograph commercial Interior images for Premier Medi-Spa in Colorado Spring, CO. This photo of Linda (plate 147) was a last-minute idea to replace the old advertisement for the spa. I had not planned on using a model, but was intrigued with her happy spirit and asked her if she would model. She turned out to be not only a beautiful model, but a great help for the entire shoot. Using the Commander mode on my Nikon D-200, I set an SB-800 (at –1 stop) at a 45-degree angle to the subject at camera left. A second SB-800 (at half power) was placed to camera right. A slow shutter speed was essential to record the flames of the candles. The result is a beautifully lit location portrait—and to quickly provide my client with an artistic alternative to the color image, Kubota Imaging Tools came to the rescue. With Kubota Actions Vol. II v. 2.3, I

I had not planned on using a model, but was intrigued with her happy spirit . . .

PLATE **147** (LEFT)—*The original image. (Shutter priority mode, ISO 100, ¹/₆ second, f/3.5)*

PLATE **148** (FACING PAGE)—*Image retouched using Kubota Imaging Tools.*

selected the Daily Multi-Vitamin to make the image pop, Smokeless Burn, NEW B&W, and Edge Blur (modified to my taste), then added a black border with keyline. The result is shown in plate 148 (previous page).

I conceived and created plate 149 back in 1989 while living in El Paso, TX, but it remains one of my favorite photographs. Keep in mind, this photo was made *before* Photoshop. It is a single negative made with a Bronica SQAM medium-format camera. I envisioned the concept, had the mirrors cut to my specifications, found sand dunes, and asked soldier Mark Lopreiato to model.

An incident exposure reading was made of the available light and my Sunpak 522 flash was set one stop more than the ambient-light reading. We had a great time on the shoot—even though our trucks got stuck in the sand dunes and we had to be towed. What fun times! My dear friend, Lynn Russell mentioned this image would be an appropriate final image in this book because it represents the start of my passion for learning lighting and photographing people. Throughout the years, I have played with this photograph to see if I could create a different feeling. For plate 150, I used Kubota Actions Vol. II v. 2.3, with Smokeless Burn for sky, and—my favorite action—Modern Antique (again, modified to taste).

PLATE 149 (RIGHT)—*The original image. (Manual mode, ISO 100, ¹/₆ second, f/3.5)*

PLATE 150 (FACING PAGE)—*Image retouched using Kubota Imaging Tools.*

Finding the Subject's Inner Light

We have discussed in some detail how to produce portraits of technical excellence by using studio strobe, available light, and a mixture of both. All of these sources help us to produce a pleasing outer light in our portraits. Beyond achieving technical mastery of light, positioning, color, and composition, however, we must also find our subjects' inner lights. As a professional photographer, you have the challenge of finding your subject's comfort zone, of finding a way to create a portrait that captures your client in his or her best light—or as he or she *wants* to be seen—and reveals that sparkle of light in their eye.

You have the challenge of finding a way to create a portrait that captures your client in his or her best light.

You will be dealing with a wide variety of clients. Some may not feel comfortable in front of a camera, some may have been forced by a loved one to visit your studio, others may have had a bad day. Some will arrive with an easy smile, others will not. Either way, it is up to you to create portraits that exceed your clients' expectations. This can be a daunting task, but you will be rewarded with a great sense of achievement when you hit your mark. In your pursuit of portrait excellence, I suggest giving the following suggestions your best shot:

1. Work to connect with your clients. As an icebreaker, arrange a consultation to find out their vision of the portrait: family, fun, traditional, or edgy.

2. Keep your clients involved throughout the creative process— from clothing choice to selecting the desired props for the portrait. This will help them feel more comfortable. Remember, if they just wanted a quick snapshot, they would have gone to a chain store.

3. Educate your clients about what it takes to make a beautiful portrait. Explain that their eyes and shoulders should never be on the same plane, tell them why men and women are captured with different lighting requirements, and give other examples as needed.

4. Ask clients to bring their favorite music along and play it during the session. Let them know the first ten exposures will not be

used, so they will have a chance to get comfortable in front of your camera.

5. Find one feature on your client that is truly striking—whether it's the eyes, hair, or cheekbones—and compliment them on that feature. Your goal here is to help your subject feel more relaxed and positive, which produces amazing portraits.

6. Don't be afraid to show your own vulnerability if it helps to put your client at ease.

7. Genuinely enjoy your experience with your clients and have fun.

Clearly, photography is a people business. If you aren't someone who genuinely enjoys being around a variety of people, or someone who has the patience to create a comfort zone for your clients, you just may need to rethink your profession. If you have the right people skills, however, combining them with your technical knowledge of lighting will allow you to create spectacular works of art. It will also win you the loyalty and appreciation of a wide clientele.

Index